A VICTORIAN MARITIME ALBUM

A VICTORIAN MARITIME ALBUM

100 Photographs from the Francis Frith Collection
at the National Maritime Museum

Chosen, Introduced and Explained by

Basil Greenhill
Director of the National Maritime Museum

Patrick Stephens Limited
Cambridge

First published – 1974

ISBN 0 85059 170 8

Printed in Great Britain by offset lithography on
118 gm² white Castle Art paper and bound for
the publishers, Patrick Stephens Ltd, Bar Hill,
Cambridge, CB3 8EL, at the University Printing
House, Cambridge

Designed by Martin Treadway

To Douglas and June Henley

CONTENTS

FOREWORD

The idea of compiling this book came from the publisher Patrick Stephens himself, who saw a copy of an article I wrote for *Country Life* when the National Maritime Museum acquired many of the maritime photographs in the Francis Frith Collection. We welcomed the idea of making a selection of the best of these photographs available to a wider audience and the publication of the book is in accordance with the Museum's policy of publishing selections from its great photographic archive in book form. It is, indeed, the fifth book of photographs to have been published as a result of this policy in the last four years, each covering some part of the collection, and another book is in preparation at the time of writing.

I am most grateful to the Trustees for putting the necessary facilities at my disposal to make the preparation of this book possible, and to my fellow members of the Staff of the Museum who helped, particularly Brian Tremain, the Principal Photographer and his team, the quality of whose work rivals that of Francis Frith himself, and Alan Pearsall, the Museum's Historian. I am also most grateful to Captain W. J. Slade for his help with some of the descriptions of photographs depicting coastal trading vessels.

Bohetheric 1974 Basil Greenhill

FRANCIS FRITH & COMPANY

The coming of the railways in the last century resulted in a revolution in people's habits only equalled by the effects of the motorways in recent years. Before the railways few except those whose business it was to travel, or the well off, moved very far from their homes, except perhaps to make inland migrations from the country to industrial towns. Many people lived and died without travelling very far from the parish in which they were born, leaving it perhaps on very few occasions in their whole lives. Even after the development of the railway network, movement was by no means so great as it is now. But more people became more mobile than ever before and travel and tourism, both inside the country and abroad, began to be possible for people other than those in prosperous circumstances.

The development of the railways, tourism and the photograph as a popular medium of information were in some ways complementary. Photography's uncertain beginnings coincided with the spread of the railway network in the 1840s. At the same time as satisfactory and practical methods of photography were developed, a market for topographical photographs came into existence among potential travellers and those who wanted souvenirs. The railways which took the passengers could also carry the early photographers with their cumbersome gear. Photographic companies sending their skilled men around with their equipment could, with relatively small capital investment, build up large collections of topographical photographs. These could be sold again and again for advertising purposes, for use in guide books, and as decorations and advertisements in the very railway carriages which made them possible – it is only a few years since the last carriages lined with photographs above the seats passed out of use. However, it was the postcard industry which was to make big business of photography of this kind and to make it commercially profitable to build up libraries of scores of thousands of glass plate negatives.

The glass plate negatives of these pioneer commercial photographers were often of superb quality. Indeed to the layman it seems that few modern photographers can better the detail, composition and texture of many of even the very earliest of these ancient plates. Photography was a new skill and had all the fascination of something never possible in history before. It was taken very seriously indeed and not for the least reason that it was extremely difficult. All the earliest photographs in the Frith Collection, indeed all photographs made before 1870 or so, were taken on glass plates. These had to be prepared by having the photographic emulsion applied to them by the photographer himself in his dark room or mobile dark room tent immediately before use. They then had to be carried rapidly to the camera, mounted into it, exposed and carried back to the dark room, developed and fixed on the spot, all before the emulsion became hardened, after which it could not be processed. Provided the various complex processes were properly performed and good chemicals used the results of 'wet plate' photography could at their best be superb, for the materials used gave very good definition indeed – markedly better than some modern films and papers. Of course, each photograph was treated as a separate work of craftsmanship and skill, if not of art, in an age which took such things very seriously and still took little account of time. There was no composition on the enlarger and so the quality of the picture in this respect depended on the photographer himself at the moment of exposure. Errors of composition could not be corrected without distortion in

picture size, if at all, so photographers took great care and the results of the best of them give great pleasure to this day.

Part of this pleasure, of course, is the consequence of the printing process used to produce positives. Since there was no enlargement this was a contact process and prints were the same size as the original negatives. They were daylight prints made by exposing a paper made up by the photographer himself in a frame which held it in contact with the negative plate. This exposure was made to daylight for an appropriate period which could be checked by examining the image, which was immediately visible. The print then had to be fixed. The result, the original 'sepia' or brown prints, was at its best of fine quality with clear definition and subtle tones which make it immensely attractive. The best prints were also very permanent and did not, like much modern photographic work, fade in a few years.

One of the largest of these early photographic libraries was that built up by Francis Frith and Company. Frith's life itself was almost an epitome of his age and it has recently been the subject of an admirable brief biographical study in *Victorian Cameraman* by Bill Jay. Frith was born at Chesterfield, Derbyshire, in 1822, the son of a prosperous barrel maker, or cooper, of a Quaker family. After a good education he was apprenticed to a cutlery-making firm in Sheffield but he had a serious illness from which he recovered by travelling round England, Wales and Scotland with his parents. He then began a wholesale grocery business in Liverpool. He appears to have disposed of this after a few years and become a printer, an occupation in which in six brief years he made a fortune on which he could retire at the age of 34. He appears to have started taking photographs as a hobby in the 1840s and began to sell them, perhaps as an adjunct to his printing business, in about 1850.

In spite of his very great success Francis Frith did not like business life and for a year or two travelled widely in the Middle East and Africa, taking with him his cameras and photographic equipment, and the result was the series of photographs published in the late 1850s. They were highly successful and this series both in book form and sold as a set remained in demand for years. Other books were published, either written and illustrated by Francis Frith, or using his photographs. His work in the Middle East and Africa made him famous and Mr Jay records that at a meeting of the Photographic Society in London after his return from his second expedition he was recognised and the speaker was informed that 'Mr Frith is in the House'. The Chairman then announced his presence and the audience cheered him.

Francis Frith married and settled in England after his third expedition to other continents and he then established a photographic business at Reigate in Surrey. From an early stage he appears to have had his shrewd eye on the postcard business. He set out to make for this purpose as many photographs as possible throughout the United Kingdom. To do this he had to organise a business employing many assistants, but the quality of the work which emerged from the organisation suggests that his strong influence greatly affected the work of many of his employees. Frith negatives remained of very high quality, both technically and in composition, and they retained an unmistakable style so that today one can hazard a guess that a particular print is from a Frith negative, even though Frith himself could have played no direct part in its production. How he worked does not appear to be known in detail but it might be surmised that he began like a film or television director, travelling by train and horse carriages with his production unit and generally directing each shot. He probably ended as a producer organising the enterprise, determining what should be photographed and when, and (in his case) training the production team and determining the style of the product. In the early days, at least, it appears that he frequently took his family with him. Often one of them or one of the attendant retinue of servants, without which no prosperous middle-class Victorian family travelled, appears in the picture to improve its composition or give it human interest or scale.

Francis Frith and Company became big business, the largest photographic publishing company in the world with a vast stock of negatives and prints from many countries. Francis Frith's family life was blessed with children and grandchildren, and he became again a very prosperous gentleman of leisure. After his death in 1898 the com-

pany continued, managed by his sons. Subsequently in different hands it prospered as late as the 1960s, but in 1971 it was placed in liquidation.

The collection of historic maritime photographs at the National Maritime Museum was started immediately after the Second World War and the Museum was among the first, if not the very first, of the great National Museums to recognise the significance of photographs as a social and technical archive. The collection grew slowly until the mid-1960s when a series of gifts, bequests and purchases increased its size out of all recognition. It will now be some years before the cataloguing and indexing work following on this period of expansion is completed and the material obtained can be made readily available to students and others. When we heard of the liquidation of Francis Frith and Company and that there was some danger that the huge collection of negatives and prints would be destroyed or dispersed outside the country, we sought through the agency of Dr F. P. A. Garton of Maldon, one of the most active friends of the historic photograph collection, to purchase as many as possible of the surviving glass negatives dealing with maritime subjects around Britain.

Dr Garton worked assiduously in the interests of the Museum, sorting and selecting negatives from the Frith stock, and in the end the Museum through his agency purchased some 1,200 of these negatives covering many aspects of the maritime life of Britain in the late 19th century and in the 20th century before the First World War. The heart of the maritime part of the great collection was thus saved and we were delighted to hear later that, in the end, the rest of the collection, far larger than the maritime subjects and comprising a unique record of Victorian England, had been purchased by Messrs Rothmans whose intention is, in due course, to index and restore it. The National Maritime Museum Staff will also index and catalogue the Francis Frith maritime photographs and it is then our intention to mount a loan exhibition of choice prints which can be enjoyed much more widely. Some of the material is already being used in a new gallery to illustrate the theme of small merchant sailing ships of 1870–1920. Captain W. J. Slade in his book *West-country Coasting Ketches*, a detailed record of the way of life which went on in and around the coasting trade of South-West England 70 or more years ago, drew on the Frith Collection for his illustrations.

The present book, containing a selection of 100 of the best and most interesting subjects, will help to make this superb material more appreciated and available to a much wider audience. The illustrations have been made from prints specially prepared by the Museum's Photographic Studios, under the personal direction of the Principal Photographer, Brian Tremain FRPS. These prints have been obtained from the negatives, some of the earliest of which were possibly made by Francis Frith himself, or at least under his supervision.

The photographs reproduced here are all of great interest for the light they cast on social and industrial conditions around the coasts of Britain before the First World War. Some of the earliest of them can be dated back to the 1870s and one to the 1860s. The photographs cover many aspects of the coast line of Britain, but inevitably, considering that they were taken for eventual use as picture postcards, it is the holiday areas which are covered best. In the south-west of Britain, holiday-making existed alongside a long-surviving sail and oar inshore fishing industry, and a sailing coastal trade. This was particularly true in Devon and Cornwall, and these counties are especially well illustrated in the parts of the book which deal with the inshore fisheries and the small ports and harbours of the coasting trade. It has been said that Francis Frith did not want to illustrate social conditions or to make an historic record of the way of life of his times, but that like a modern popular travel magazine he wanted to show the best of all possible worlds. Consciously or unconsciously he and his staff broke this rule, if indeed it ever existed, when photographing in small harbours of the far south-west, for the ways of life some of the earliest photographs reveal are now quite forgotten and seem almost primitive today.

To take one instance, there is plenty of evidence in the form of abandoned lime kilns, ruins of small quays, mooring places and so forth to show that in the 18th and 19th centuries small sailing vessels used to run what look now to have been serious risks, putting ashore on open beaches

on both coasts of the Bristol Channel, around the coasts of Wales and on the south coasts of Cornwall in order to land small cargoes of goods for local communities. These goods were then discharged, often by the vessels' own crews, working with hand winch and baskets, performing as a matter of routine great feats of physical labour to earn a little margin on subsistence income; they were paid less than 1p per ton for the work of discharging 80 tons of stone or coal even as late as the 1920s. The goods, such as coal, manure, stone for the roads and feeding stuff, were taken from the beaches in farmers' carts and in some cases we know that the hire of these carts was paid for by handing over a small part of what they carried. The whole operation would be organised and financed by a local merchant who was usually the only person who made any real money out of the operation at all. This kind of shipping business was the foundation of the life of more than one harbour village in the southwest, and some of the Cornish and Welsh coves which nowadays seem unsuitable even as a base for dinghy sailing were a scene of regular trade year in and year out. Captain W. J. Slade has described in detail the working of this kind of shipping business in *Westcountry Coasting Ketches*.

The Frith Collection contains a few photographs showing the actual business going forward, and two of them are reproduced in this book. They show little merchant ships discharging at Porth Gaverne in North Cornwall and lying to moorings on the flood tide in Combe Martin in North Devon. Both photographs show vessels moored to big posts provided for the purpose. These are driven deeply into the beach and their presence shows regular trade on to these beaches at the times when the photographs were taken, the 1860s in the first case and the 1890s in the second. The names of some of these vessels are legible on the original negatives with the aid of a powerful glass, and from shipping records it is easy to confirm that the ships illustrated were owned in the neighbourhood and in one case, even, a vessel shown was built on the beach in which she is seen lying discharging her cargo of coal. This particular vessel, the smack *Electric*, which is shown in Porth Gaverne, was built there over a century ago, but she was by no means the oldest vessel that appeared in a Frith photograph. To take two examples, the schooner *Vine*, in Plate 40, was built in 1846, and the ketch *Providence*, in Plate 91, as long ago as 1805.

Most remarkable perhaps, a number of the photographs are so clear that it has proved possible with the aid of elderly people from the places illustrated to identify a few of the actual people who appear in them. Indeed one of my favourite photographs in the whole collection, which is not reproduced here, shows in early middle age the Master Mariner who as an old man taught me how to handle a lug-rigged boat at Appledore many years ago.

A few of the places illustrated have changed beyond all recognition. In the collection there is a picture of a smack discharging a cargo in the stone-walled harbour of Hartland Quay which was completely destroyed by the sea in 1896. Even more impressive perhaps is the photograph reproduced in this book showing six big schooners and two ketches lying in the busy commercial harbour at Pentewan in South Cornwall. Today the entrance to the harbour is completely silted up and is indistinguishable from the beach. The water in the dock is cut off from the sea and a caravan park fills the wilderness of saltings seen to the west in the photograph. At the time this photograph was taken Pentewan was still quite a thriving centre with houses and inns, and a railway to bring the china clay which comprised the principal export down to the ships, as well as an efficient system of quick loading.

Of course, many photographs depict aspects of the fishing industry that once played such a part in the life of seaside villages and towns. A picture in this book of Sutton Harbour at Plymouth illustrates vividly the truth of the words used to me by an elderly seafaring gentleman many years ago: 'The vessels were so thick in here you could walk across the harbour by stepping from deck to deck.' These were not efficient fishing units by modern standards, but each provided a living, or part of a living, for several families, with much hard work and considerable risk of capital.

Beach fishing was an extremely hard way of life and this fact comes out very clearly in Frith photographs. There is no question here of his concealing or being able to conceal the reality which lay behind the charming scenes he and his staff selec-

ted. The photographs taken on the north-east coast, the then lonely little coves filled with the local boats called cobles, which were the sole support of the local communities, lying on a beach behind a wall of surf, give some indication of the sort of life that must have been lived there. The way of life is described in detail in the unique contemporary writings of Stephen Reynolds, most notably in his book *A Poor Man's House*, and the part of England about which he wrote, South Devon, is illustrated in a number of photographs we have reproduced here. Stephen Reynolds was himself responsible for the introduction of pioneer marine engines to the fishery in this part of England, and one of the photographs reproduced in this book, taken perhaps during the First World War or just before, shows early motorised boats lying on the beach while their owners and crews engage in the endless work of repairing the natural fibre nets on the beach.

To live as a beach fisherman in the last century, Reynolds has shown, meant endless toil in which there was no room either for ill health or for prolonged bad luck. Either probably meant utter disaster for, unlike the coasting seaman, the beach fisherman had little or no opportunity of building up capital and improving his position. The boats were open because they and their heavy gear had to be hauled on to the beach by hand each time they came in from fishing, and in periods of bad weather they had to be pushed further up than is shown in the summer season photographs in this book. Any form of decking would have made handling more difficult and the boats heavier, but its absence meant a working life almost completely exposed to the weather at sea. There was no place for warm food and even hot drinks could only be prepared with difficulty. There was nowhere even for the men to keep dry. When not at sea the nets, the beach fisherman's only asset except for his boat, had to be looked after continually from season to season. At home they lived in stone-floored cottages without running water, sanitation or lighting, cooking their food in coal-fired ranges or stoves, and using candles and cheap oil lamps.

There are, of course, numerous photographs in the collection showing the way people enjoyed themselves at the seaside and indeed the selection of photographs depicting this subject in the first section of this book is one of the largest. Here again the social commentary is unavoidable. These are the relatively monied people who came to stay; they spent their money and gradually this fact became more and more important in the local economy and the gulf between them and the local inhabitants, at first so vast, narrowed. And in what ways they enjoyed themselves – bathing machines and tents, donkeys, trips around the bay, adventurous voyages by paddle steamer, piers and sailing boat trips.

But the Frith photographs do not deal only with picturesque small harbours and coastal villages and people enjoying themselves on the beach. There are some photographs which depict the busy great ports – Liverpool, Swansea, Barry, Grimsby and Hull – all smoke begrimed and rough as they were, with the big steamers coaling from barges or discharging into them. But pleasure steamers, fishing boats, and the schooners and ketches of the coasting trade are not the only vessels depicted in this book; there are also photographs, among the finest ever taken, of liners which carried thousands of square feet of sail on masts and yards bigger than those of most contemporary sailing ships, of tugs and steam colliers, of barges and river craft, and of warships and yachts.

This book depicts human life as it was lived in the small harbours, the big docks, on the beaches and in the villages around the coasts of Britain before the great divide of the First World War. The photographs that do this are a tiny selection of the vast number prepared under the influence and in some cases the direction of one of the world's first great photographers. They are an important historical record, a human document and a reminder of how life in Britain has changed, mostly for the better for the majority of people, in the years since 1914. We have called it a Victorian Maritime Album because most of the photographs were taken in Queen Victoria's reign. Others were taken in the years before the First World War in a society comparatively little changed from that of the previous reign. The album, then, might have been begun by one generation of a family which visited the seaside in the 1880s and finished by the next in 1914, with a few photographs added by grandchildren in the 1920s and 1930s.

Section 1
BESIDE THE SEASIDE

The habit of visiting the seacoast began in the latter part of the 18th century, largely as a result of the efforts of doctors who in the 1750s began directing patients to go to the seaside when they could afford it. Thus gradually began the seaside holiday habit and sea bathing, at first on a small scale and confined to those who could afford expensive slow transport and costly accommodation. But in due course, with the coming of the railways, the habits of the gentility could be adopted by the mass public, if only for a day or two at a time, and the large-scale growth of seaside resorts began and has continued in varying degrees ever since. Soon the seaside became part of every child's life, so that Lewis Carroll could write in *Alice in Wonderland* that Alice 'had come to the general conclusion, that wherever you go on the English coast you find a number of bathing machines in the sea, some children digging in the sand with wooden spades, then a row of lodging houses, and behind them a railway station'.

With the arrival of the general public their presence could be exploited by more vulgar attractions. The seaside pier developed, and so did excursions around the bay, longer steamer trips, and eventually a multitude of entertainments, from country fairs to dances and bioscope shows, as well as the bathing which had started it all.

Plate 1

This is Bridlington, Yorkshire, on a busy day for visitors at the harbour, sometime before the First World War. The big local sailing boats called cobles, used normally for fishing, are carrying passengers out of the harbour instead, no doubt with greater profit and much less toil. They appear to be doing a booming business and they are probably not giving people simple sailing trips, as the ordinary

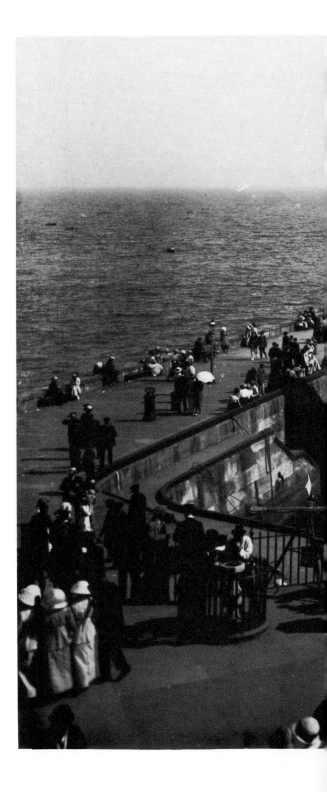

beach pleasure boats did, but an opportunity to do a little line fishing themselves – always an exciting experience.

There is a shining brass telescope (you can climb up steps to look through it, probably for twopence per time), a sundial which is attracting the detailed study of two men, and a group of schoolgirls in summer uniform who appear to be having something explained to them on the left, or it may just be that the man, apparently a fisherman, who is with them is trying to persuade them to take a boat trip. It is a very hot day and a lot of people have walked out on to the pier to greet, or perhaps take a trip in, the paddle steamer which passengers are boarding via a gang plank leading from the pierside to the bridge, a perilous arrangement. At the moment the photograph was taken a woman was half way down the plank, poised over a 20 foot drop into the water.

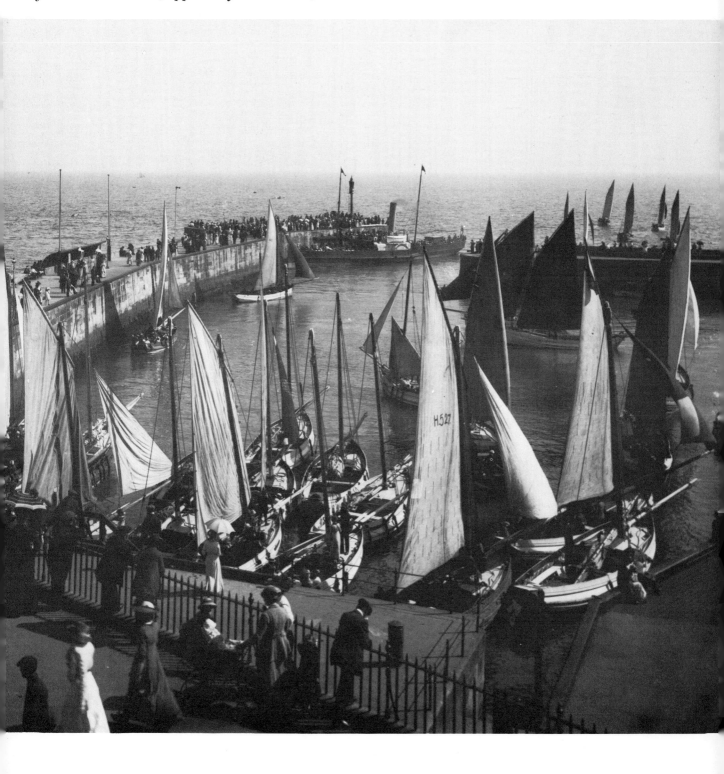

Plate 2 (Below)

Probably taken in the 1870s, this is one of the oldest photographs in the book. The location is not known but it would appear from what are apparently the masts of spritsail barges in the background to have been somewhere on the south-east coast. I have included it because it illustrates bathing machines so well. When doctors started prescribing bathing in sea water as a cure for anything from asthma to diseases of the glands the bathing machine, or bathing chariot as it was first called, was invented to make the process easier.

The method was simple; the bathing machine with its big wheels was kept on the tide line of a gently shelving beach by means of mooring ropes which were slackened off or pulled in depending on whether the tide was ebbing or flowing. The bathers entered at the dry land end by means of steps or a plank, changed in the machine and left privately by climbing a ladder down into the water, bathed, climbed up the ladder and dried themselves and changed back again inside the machine.

The arrangement was not only very natural to a society in which prosperous people did not appear in public except fully clothed, it was also perfectly appropriate when the whole idea of sea bathing was novel and regarded as a form of private medical treatment rather than a relaxation.

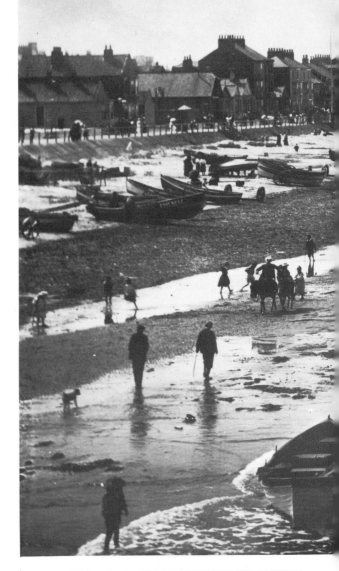

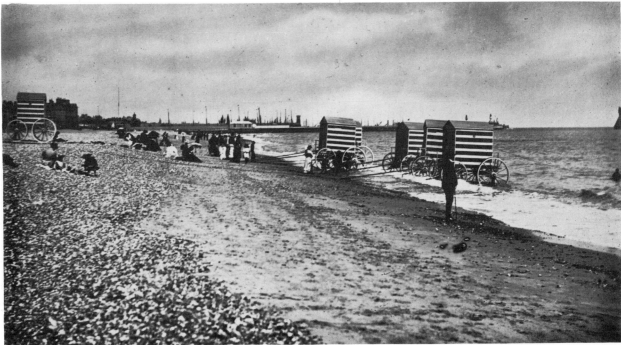

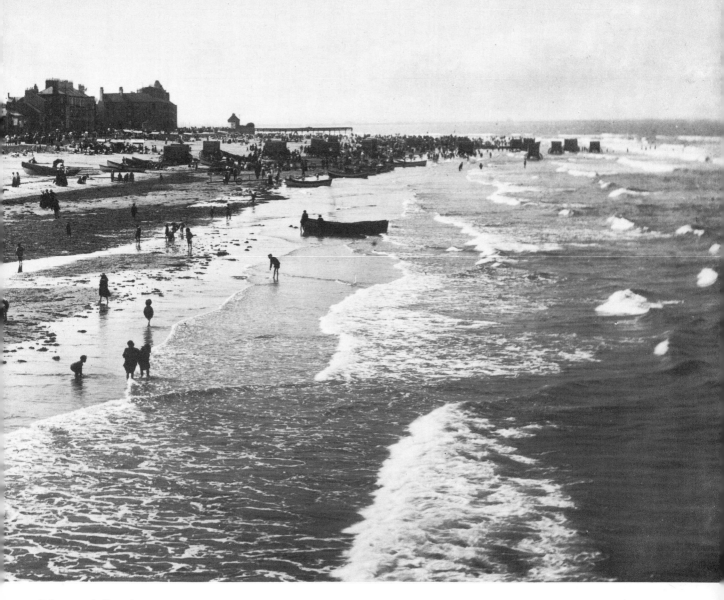

Plate 3 (Above)

This view of the beach at Redcar in Yorkshire shows many of the attractions of a small seaside resort. There are donkey rides on the sand, boat trips off the beach (here the boats are launched by means of pairs of wheels) and bathing machines, some of them advertising Pears soap on their sides, in reserve and in use. A few of those in use can be seen right out in the surf with their bathers in front and around them, and one of the machines appears to be half submerged. One of the recognised relaxations was to watch people emerging from bathing machines through telescopes where the geography made this possible. In his book *Brighton, Old Ocean's Bauble*, Edmond W. Gilbert quotes a writer of the early days of bathing machines who said that the bathers 'are all severely inspected by the aid of telescopes, not only as they confusedly ascend from the sea, but as they kick and sprawl and flounder about its muddy margins, like so many naiads in flannel smocks'.

This beach is well crowded, particularly at its northern end and a number of people are paddling.

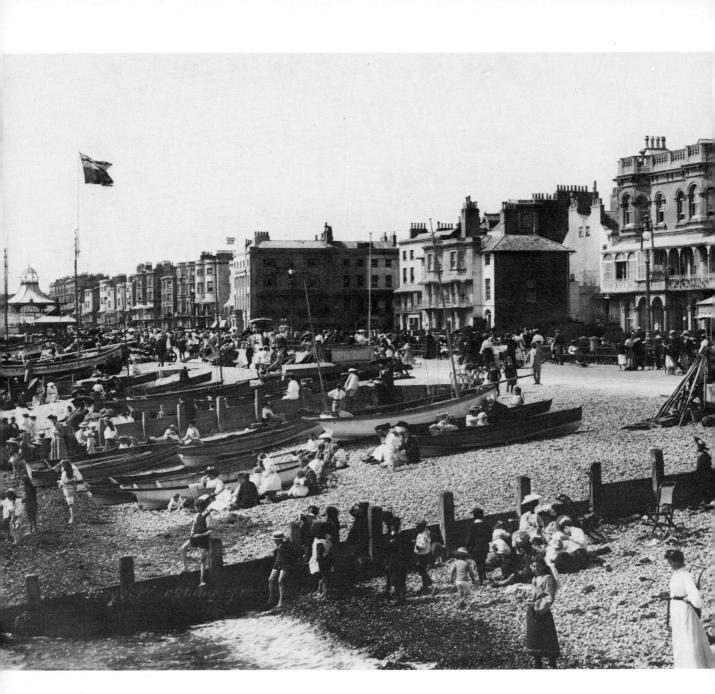

Plate 4

In this excellent photograph the beach of Worthing goes straight up to merge with the foreshore road. There is a typical beach shelter on the right and a bandstand in the distance on the left. The whole thing is a happy jumble of fishing boats, pleasure boats, holiday makers and tradesmen who provide for them with the inevitable boarding establishments facing the sea. The bare-legged boys in the foreground are able to paddle easily; one retains his boater. It is more difficult for the girls and the one on the left of the picture has hauled up her skirt to reveal knee-length knickers. She is determined to get her feet wet.

Plate 5

I am particularly fond of this photograph, taken in the early 1880s at Weston-super-Mare in Somerset, because I was born more or less in sight of this same view, though half a century later.

Weston-super-Mare is a product of the 19th century. In 1801 its population was 138; seven years later it got its first hotel and soon after it was linked with Bristol by a regular four-horse coach. Paddle steamers began to visit Weston-super-Mare regularly a few years later, but Weston's great leap forward was taken with the opening of the Bristol to Bridgwater part of the Bristol and Exeter railway in 1841. When the rather smart crowd in this photograph was sunning itself one warm day almost a century ago Weston was a prosperous resort.

Pleasure boating from the Anchor Head Slip shown here was one of the most popular recreations for visitors. The boats shown are of a very special kind, although they look like ordinary clinker-built sprit-rigged sailing boats; in fact they are flat-bottomed. They are the classic example in Britain of a type of round-sided, flat-bottomed clinker-built boat which, as far as is known, did not appear elsewhere in this country, but was widely used in Europe and North America. The boat on the far left is another example of an interesting local type, the Bridgwater flatner, known in Weston-super-Mare as the dory, and the British version of a type which is widely used around the coasts of Europe and even more widely still in eastern North America. This one is particularly interesting because most flatners were built with solid sides cut from two very wide planks of elm, scarfed together amidships. But this one, photographed at a time when flatner building was at its height, is like a Portuguese or Canadian dory, built clinker fashion with five strakes aside.

The sailing vessel at anchor with her gaff mainsail scandalised just offshore is probably a Bristol Channel pilot cutter. The two smack-rigged vessels in the background, each towing a boat, are Severn trows, the local sailing barges of the inner Bristol Channel (see Plate 91).

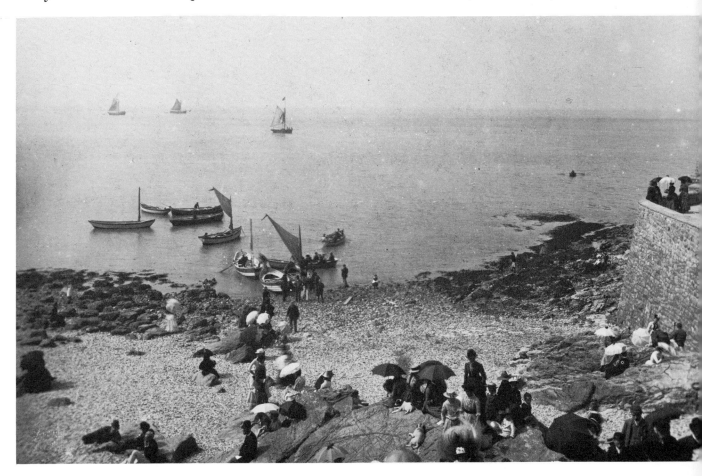

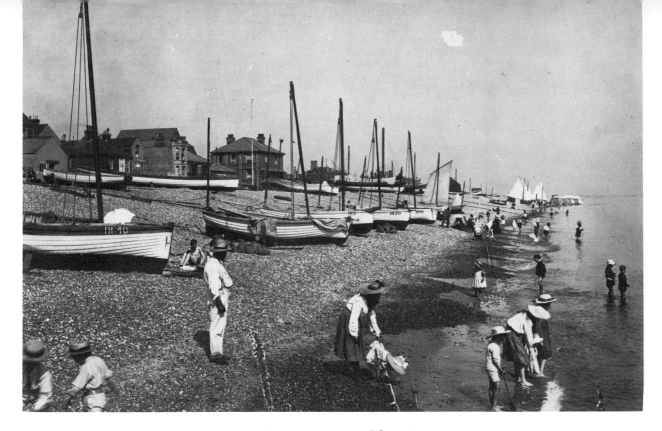

Plate 6

In this photograph of Aldeburgh taken somewhat later the local beach fishing boats, here rigged with dipping lug sails, are hauled out at the southern part of the beach. Away at the northern end the pleasure boats with their gaff sails and gaff topsails are lying awaiting their freights of passengers in the neighbourhood of the bathing machines. At least two of the latter are fitted with canvas hoods on the seaward side so that the steps are obscured and the process both of entering and leaving the water can be conducted decorously with no fear of examination through telescopes. Bobbing heads are visible in the water below the machines.

The younger people in the immediate foreground confine themselves to paddling, while the E. Nesbitt girl in the centre of the picture holds on to the skirts of a younger sister, vigorously assaulting the sand with a wooden spade, even though the tide is 10 feet away from them. The boys are allowed much more freedom. One is picnicking by the bows of I H 40 dressed only in bathing trunks, although this photograph, from its serial number, was taken in the very early 1900s. This is a much more select resort than some of the others illustrated. Distance and poor railway communication prevented growth until the arrival of the motor car.

Plate 7

This beach pleasure boat, shown at the turn of the century, operated at Brighton. Not unexpectedly her shape appears to be influenced by the local fishing boats and she is square sterned. She is very heavily rigged with a big mainsail and a gaff topsail, as well as her standing lug mizzen. These boats were removed from the beach by means of a hauling-off rope secured to a mooring. The rope can be seen coming in over the bowsprit, but this boat is not yet ready for hauling off. A gang plank is visible from the beach to her port quarter and she is in fact lying on the tide line still loading her freight of passengers. On this summer's afternoon she will lie like this each trip, but at night time, or when the weather makes working impossible, she will be hauled up the beach on skids or rollers by means of a winch.

Trips in a boat like this, at perhaps 2s (10p) a time, were a great treat. As they were very skilfully handled by professional crews who spent much of the year fishing and were rather bigger and much more heavily rigged than most modern yachts, they gave their passengers an experience of sailing hard to parallel today.

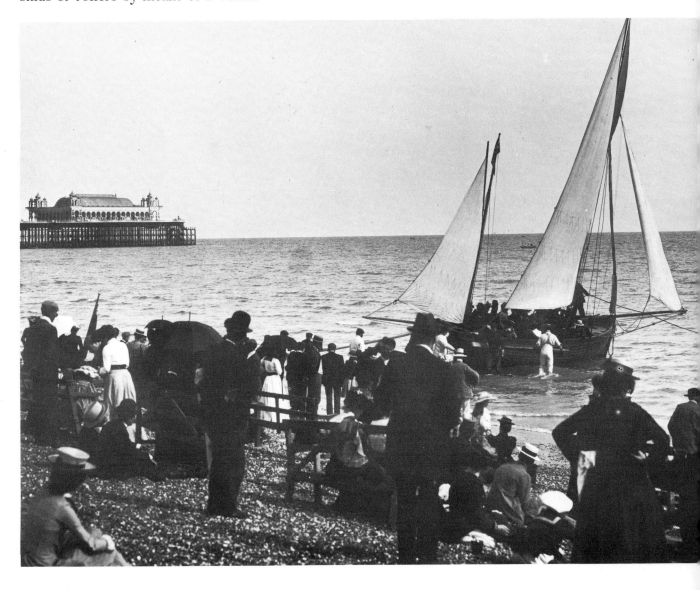

Plate 8

Here is the same boat, from the serial numbers two plates later and probably on her next trip. She is just about to sail off the beach and has a smaller freight of passengers than before, but the master, who is visible by the stern in Plate 7, about to board the vessel, is now standing at the tiller. The bow rope has been cast off and the vessel is just about to fill on the port tack which will take her out towards the pier head. Notice the long sweep on the port side; the corresponding sweep on the starboard side was visible in the previous photograph. These would be used if, in the evening, the vessel became becalmed with a load of passengers.

These passenger trips were a great feature of seaside holidays in the late 19th century and until the First World War. They have, of course, their modern equivalents in motor boat trips but it is difficult to believe that these give quite the same satisfaction as the adventure of a sail in one of these little working ships must have done.

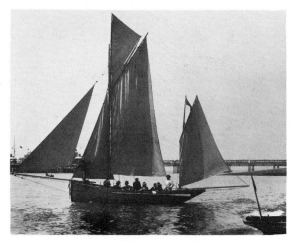

Plate 9

One of the later photographs in this book, this picture was taken on the shores of Morecambe Bay and shows children playing on the sands exposed by the ebb tide. Its special interest is that it shows examples of Morecambe Bay prawners or Lancashire nobbies, dried out on the sand, one of them in a rather perilous position, which can be doing her no good at all, lying diagonally across the ridge.

There were three usual sizes of nobbie; these are the smallest, 25 feet long. The boats were developed for prawning and

shrimping in the waters off the Lancashire coast and down towards North Wales, and for working among sandbanks and strong tides in the steep seas of shallow water. They were quite unlike any other local fishing craft of the British Isles and their general appearance was more like that of some old-fashioned yachts than most working boats.

They were also used for passenger pleasure sailing and Captain Peter Norton has a lovely description of this use in his book *The End of the Voyage*: 'Some years ago, I lay off Fleetwood and watched with mingled anxiety and admiration, crowds of nobbies, their cockpits packed with holiday makers of doubtful buoyancy and of all ages and sexes, their decks a welter of swirling foam and water, working out through the tearing tide of the narrow entrance to the harbour. . . . They tore along, tacking through the choppy waves of the Channel, with Ma clutching her hat, Pa trying to rescue little Emmy from the scuppers, and young Albert being sick, but all having the time of their lives.'

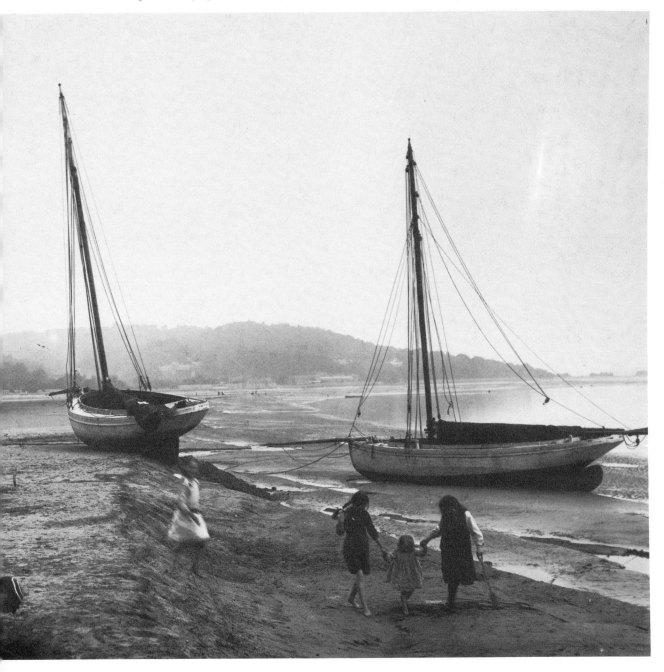

Plate 10

Complementary to the sailing boat trips were the cruises in paddle steamers, some of which lasted for an hour or two, some for a whole day. Steamers worked from harbours, as in Plate 1, from piers – see Plate 13 – and from open beaches.

In this photograph taken at Seaton in Devon the paddle steamer *Victoria*, built in 1884 and running in service on the south coast, is landing passengers by means of a gang-plank rigged out from her bows straight on to the pebbles of the beach, an interesting process which has attracted a large crowd. The beach goes down steep here, which has made it possible for the steamer to come right inshore at this state of the tide.

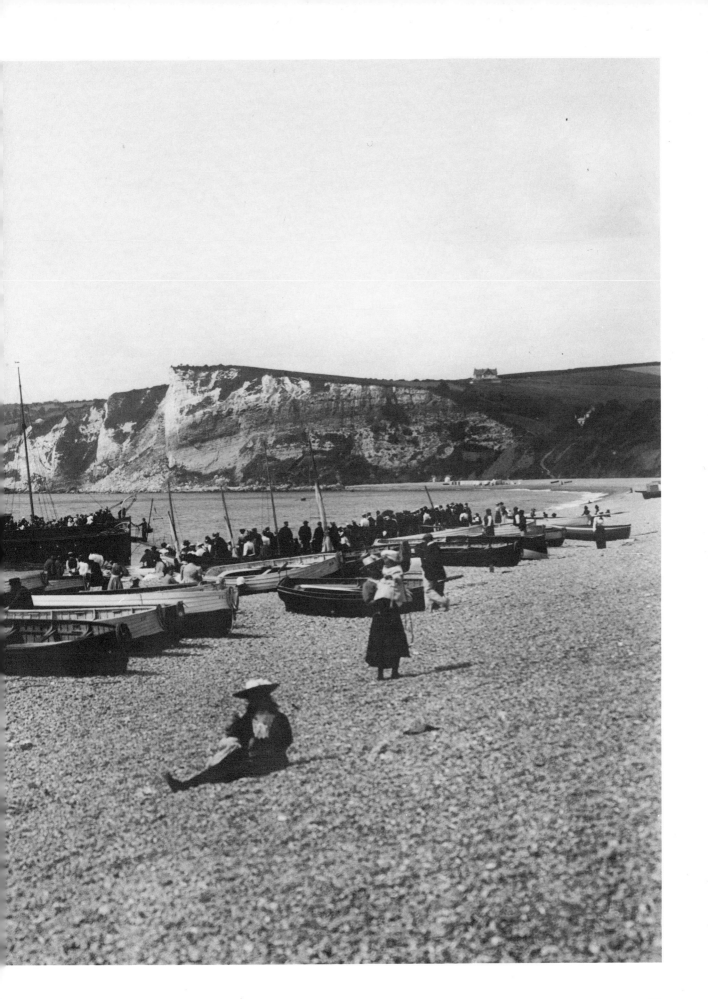

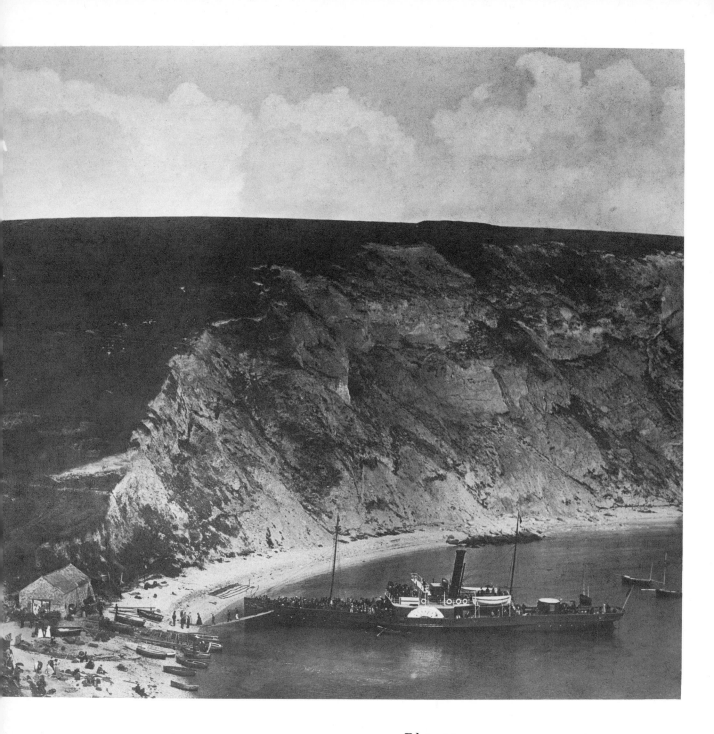

Plate 11

The process of beaching steamers is shown all the more clearly in this photograph of the *Victoria*, taken some years before Plate 10, landing her passengers in Lulworth Cove. A woman is just about to step ashore from the gang-plank and three men are walking down behind her. There are quite a lot of people on this busy working fishing beach; the four-wheeled cart with a pair of horses is probably a conveyance for taking people up the valley.

Plate 12

he pier, as a place for walking, entertainment, steam boat landings and embarkations, was essentially a product of the 19th century, when it became a feature of seaside resorts. In fact, no resort was complete without one.

This is the old Plymouth Promenade Pier, built in 1882 and finally destroyed in the Second World War, photographed at 11.45 one warm breezy summer morning, at the beginning of this century. Drake's Island is in the background and lying off it the Naval training brigs (see Plate 17) and a number of yachts. This area has remained associated with yachting ever since and the low building between the road and the little harbour on the right of the picture is now the headquarters of the Royal Western Yacht Club of England.

Apart from the removal of the pier, this view is almost exactly the same today as it was when this photograph was taken. On the whole the appearance of the Sound has been improved by the pier's demise.

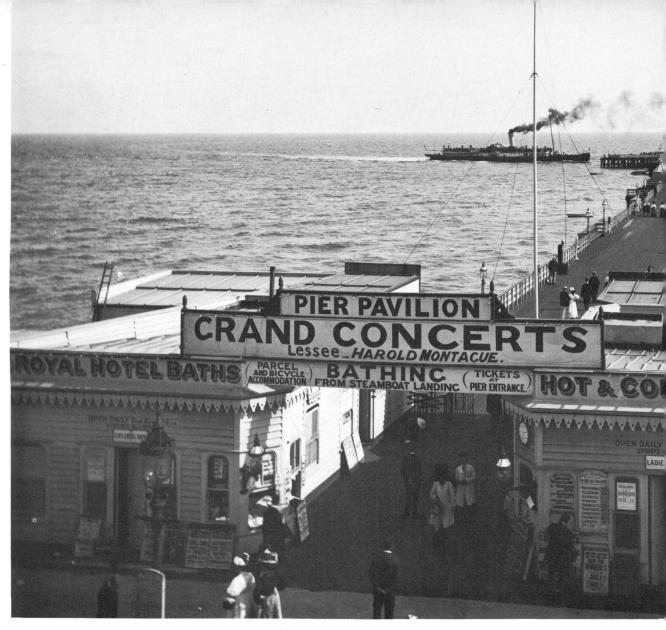

Plate 13 (Above)

In contrast with the Plymouth pier this east coast one is constructed of wood and the photograph emphasises two of the main functions of piers, to be the landing place and point of embarkation for the passengers on the local paddle steamer service and to provide entertainment in the pier pavilions or theatres. There was a third important function – the piers provided an area for social recreation, strolling, meeting people and gossiping.

Apart from the conspicuously advertised concerts there were regular steam boat services to this pier. At two o'clock a boat is advertised as heading north for Walton, Felixstowe, Harwich, Ipswich and Yarmouth, and at four o'clock south-east for Southend, Gravesend, Fenchurch Street and London.

Plate 14 (Below)

This old photograph, dating from the early 1880s, of Cullercoats on the Northumberland coast has a charm all of its own. The bows of the cobles with their masts, yards and oars stowed are peculiarly beautiful against the grey stone of the quay wall. The children look happy; they are very demurely dressed and the paddlers seem to be wearing some kind of uniform. It may be just a family, but I suspect they are all from a small local school.

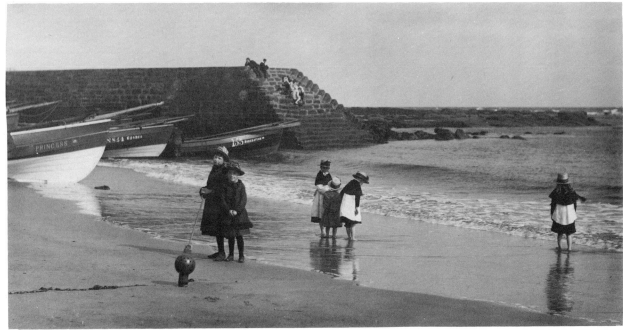

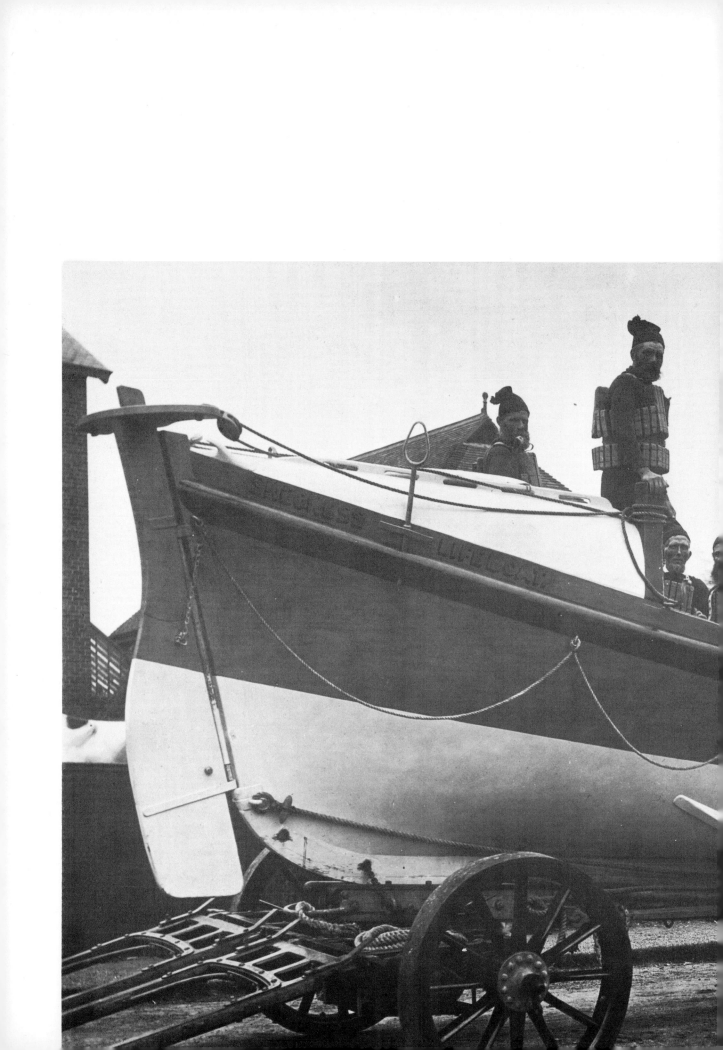

Plate 15

One of the excitements of a seaside holiday was to see a practice launch of the local lifeboat, or at any rate to see the boat itself dragged out of its shed on its great carriage drawn by four, six or eight horses.

This very nice photograph shows the Skegness lifeboat in the 1890s. She is the *Ann, John and Mary* which was stationed at Skegness from 1880–1906. She is a typical Royal National Lifeboat Institution standard self-righting lifeboat of the period and of the 37 foot by 8 foot twelve-oared variety, with water ballast tanks which were then being reintroduced.

During her fairly short stay at Skegness she saved 13 lives and she was then replaced, at the request of her crew, by a lifeboat of the non-self-righting type.

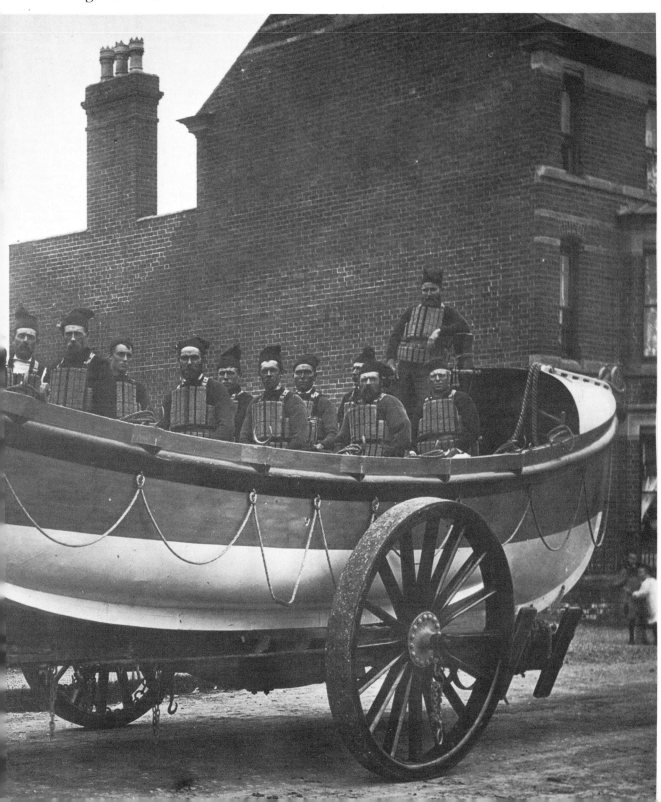

Section 2
YACHTS &
PLEASURE SAILING

Francis Frith's work took him right through the greatest years of yachting and pleasure sailing, the years when Lord Brassey's *Sunbeam* was making her great voyages all over the world, the years of the great steam yachts and of sailing yachts with paid hands galore. They had enormous areas of canvas, beautifully disposed in gaff sails, square-headed topsails, and clouds of headsails set on long-reaching bowsprits, so different from the jib-headed Bermudan sails and staysails which yachts of all sizes wear almost like a uniform today.

But, in fact, Francis Frith and his men do not seem to have photographed many of the big vessels. The small selection given here is, however, suggestive of the simpler side of yachting and pleasure sailing of the period and representative of their work. One of the four photographs represents the common man's pleasure sailing. Trips around the bay in the big powerful sailing boats of the type already illustrated in Section 1 of this book that worked off the beaches at seaside resorts gave everybody with half a crown to spare an experience of pleasure sailing in vessels of a size and complexity few can enjoy today.

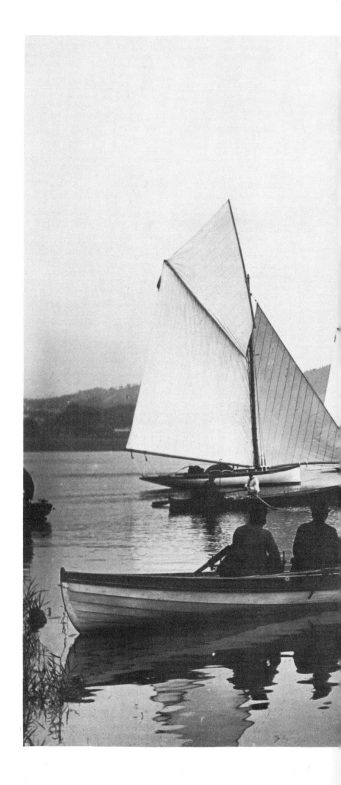

Plate 16

These elegant yachts belong to members of the Royal Windermere Yacht Club, founded in 1889. The photograph was taken not long after. They were deep narrow yachts, heavily rigged with their handsome jackyard topsails above the gaffs and their enormous spinnaker-like jibs set on the long bowsprit. The course of their races was from the ferry at Bowness up to the top of the town, down to the south end of the lake and back to the town, a course of 18 miles.

Nearly as handsome are the splendid lake pulling skiffs, so beautifully reflected in the calm close to the shore. The yachts have a light breeze, shown in the rippled surface of the lake.

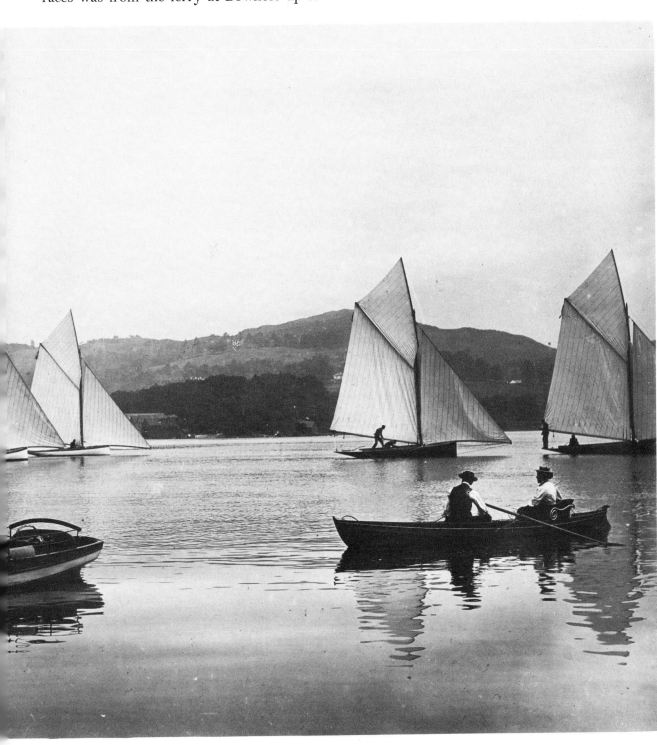

Plate 17

𝕿his view of regatta day at Dartmouth in 1886 is full of interesting yachts and vessels. Notice in particular the miniature steam yachts; the dandy-rigged one in the foreground cannot be much more than 20 feet long, while the one right in the middle of the picture may be 40 feet. You can also see that she hoists her own boat on board. The elegant schooner with the white sail covers astern of the small steam yacht shows the medium-size Victorian sailing yacht at its most handsome. The brigs are from the Royal Naval Training Fleet. There was a little group of these brigs operating until the early years of the 20th century to give sail training to the Navy's young entry, some of whom can be seen about to board the nearest brig from the cutter they are bringing alongside. These brigs have found their modern equivalent in the brig *Royalist* which provides training facilities for members of the Sea Cadet Corps.

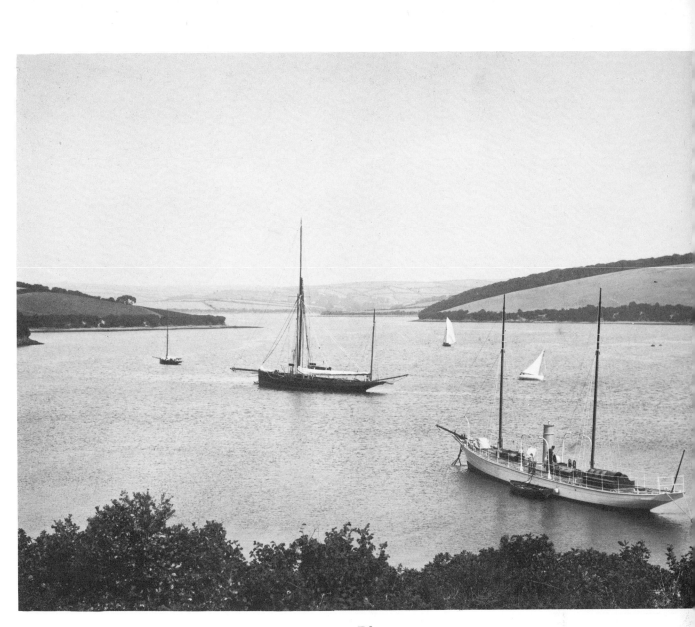

Plate 18

Steam yachts took some time to gain respectability, but by the late 19th century fully powered steam yachts without sails and of greatly varying sizes were becoming common. The one shown here at moorings in Salcombe Harbour is fairly typical: long and narrow, flush-decked with sky lights, clipper bow, bowsprit and tall mast from which gaff sails, making her into a two-masted schooner, were probably set in her early days, not because they were needed but to maintain a link with sail and give her owners some occasional sailing. The big yawl is also typical of the period, a variation on the trawlers seen in a later section of this book. Today's mass dinghy sailing is anticipated by the little boat heeling over to the breeze.

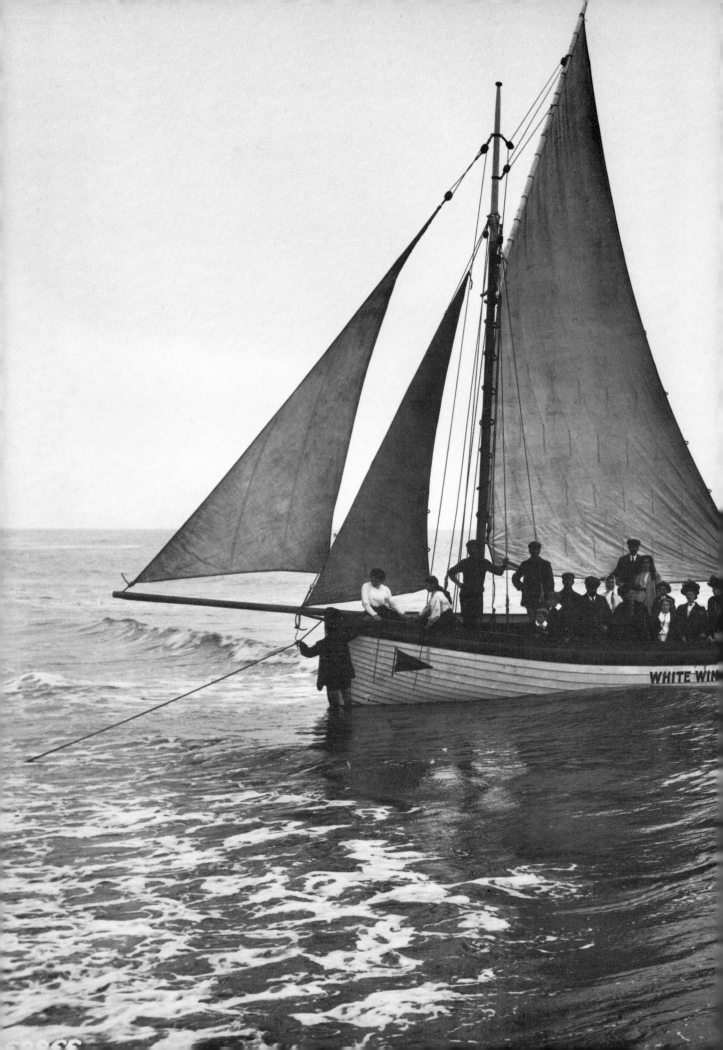

Plate 19

⑀his is pleasure sailing of a different kind. As I have already said, every seaside resort had its big pleasure boats, usually clinker-built, used for giving visitors a little taste of seafaring during the summer season. In most places these pleasure boats were launched straight off the open beach, but they were bigger than most working fishing boats and much more heavily rigged. This photograph shows a superb example, *White Wings*, in shape like a big old-fashioned wooden ship's lifeboat, seen lying crowded with passengers, men, women and children, just afloat off the beach.

She is rigged as a ketch, or rather as a dandy, because the mizzen sail is a standing lug not a gaff sail. Her shape, size and rig all correspond very closely with the description of the *Dulcibella*, the yacht in Erskine Childer's classic *The Riddle of the Sands*. Indeed, apart from the absence of a deck and cabin top, she might well be the *Dulcibella* in which Carruthers and Davis had their timeless adventures.

Section 3

WARSHIPS

When Francis Frith started his photographic business the Navy still comprised predominantly wooden sailing vessels, many of them very similar to those that had fought at Trafalgar. By the end of the century the whole picture had completely changed. Sail had been totally replaced by steam; wood had given place to iron and in turn to steel, and enormous technical changes in armaments, gunnery, communications and organisation had altered the Navy profoundly. The western world, and in particular the United States, had developed relatively peaceably behind the protection given by the presence of this great modern navy. Frith's photographs illustrate the changes very well and, of course, photographs of warships made popular saleable subjects.

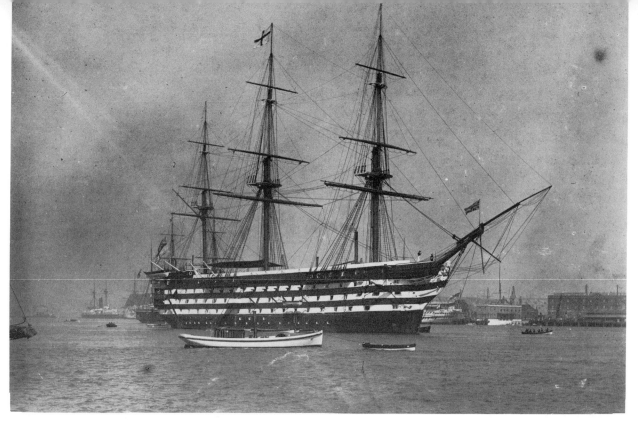

Plate 20 (Left)

Plate 21 (Above)

This view shows the Navy of wood and sail, of Trafalgar. The *St Vincent* was a first-rate of 120 guns built at Devonport between 1810 and 1815. Too late for the wars with France and the United States which ended in the year of her launch she went into 'Ordinary' for a long time and was finally commissioned in 1831 as Flag Ship in the Mediterranean, where she remained until 1834. From 1841 to 1848 she was Flag Ship at Portsmouth, still going to sea occasionally. She then became Guard Ship in Ordinary at Portsmouth from 1854 until 1862, being sufficiently in commission to go to the Baltic during the Crimean War, though only as a transport. From 1862 to 1906, when she was broken up at Falmouth, the *St Vincent* was a boys' training ship at Portsmouth, and it was during this period, in the early 1880s, that this photograph was taken. Notice the two other big wooden warships in the background and the elegant three-masted schooner-rigged steam gunboat, a vessel of the new age, on the right-hand side of the picture.

Also taken at Portsmouth, this photograph shows a most interesting vessel, exemplifying the beginning of the real changes of Queen Victoria's reign, a wooden screw steamship of the line.

She was begun in 1849 as HMS *Windsor Castle*, a 120 gun first-rate. In 1852, while still being built, she was lengthened and fitted with engines and propeller, making her the longest three-decker in the world. She was launched on September 14 1852, and as the Duke of Wellington died that day Queen Victoria ordered that the ship be renamed in his memory.

In the Crimean War she was in the Baltic as Flag Ship of Vice-Admiral Sir Charles Napier. She then became a guard ship at Portsmouth and had no more sea service. The big steam screw three-deckers approached the limit of size possible for wooden ships and they very rapidly became obsolete. In 1869 the *Duke of Wellington* became the Flag Ship of the Commander in Chief Portsmouth, and in 1891 when the *Victory* became the Flag Ship she served as her tender until 1904 when she was sold and broken up.

The photograph was taken in the 1880s when she was Flag Ship at Portsmouth. Notice the Marine Guard standing on the fo'c'sle above the great figurehead and the Admiral's flag at the main.

Plate 22 (Below)

hMS *Pelorus*, shown in this photograph, was a first-rate cruiser built at Sheerness in 1896, and the difference in her appearance from that of the vessels in the preceding two photographs is itself a measure of the naval change in Queen Victoria's reign. Her first commission was with the Channel Fleet from 1897 to 1901 and it was during this period that the photograph was taken. From 1904 to 1909 she was on the Cape Station and then in 1910/11 conveyed relieving crews out to recommission ships abroad. Her final peacetime commission was from 1912 to 1914 on the East Indies Station, largely in the Persian Gulf. During the First World War the *Pelorus* was first in the Gibraltar area, later in the Mediterranean and finally in the Aegean. She was sold in 1920 and broken up. She had twin screws driven by triple expansion engines and was armed with eight 4 inch guns and eight three pounders. She and her sisters were criticised for their weak armament.

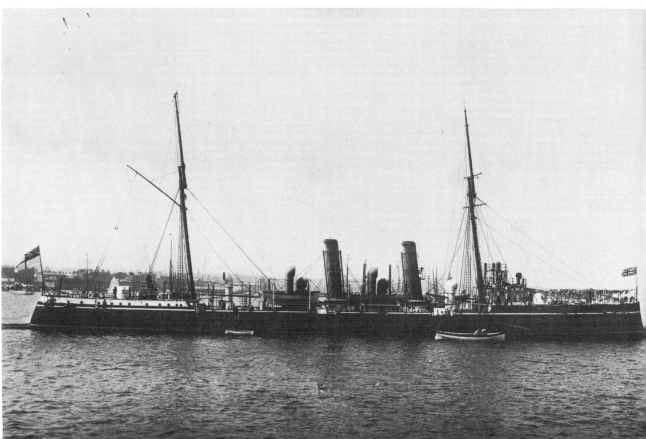

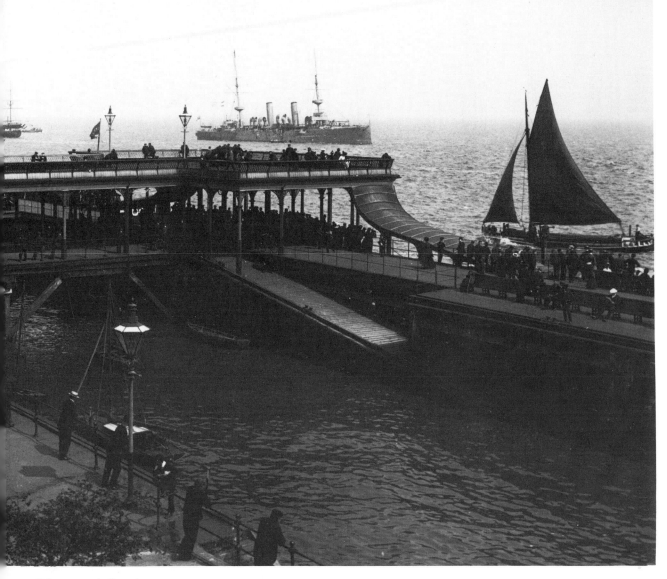

Plate 23 (Above)

This most interesting photograph was evidently taken on the same day as Plate 42, probably within an hour or two of it, the sun having come out in the meanwhile, for the serial numbers show that only one other photograph was taken in between. It shows Victoria Pier at Hull in about 1903. The main distant feature is the light cruiser *Dido*, of the *Dido* class, built in 1896 by the London and Glasgow Shipbuilding Company. In 1903 she was in the Home Fleet, and she was armed with five 6 inch guns and seven 4.7s.

Astern of the *Dido* lies the *Southampton*, built at Deptford in 1820 and used as a boys' training ship at Hull from 1867 to 1912. The sailing vessel on the starboard tack in the right foreground is a Humber sloop, the fore and aft rigged variation of the keel (Plate 41), used for carrying cargoes on the Humber and its waterways, and on the adjacent coast. A three-masted barque-rigged merchant ship lies in the distance.

Plate 24

𝕿his shows the paddle steamer *Triton*, not strictly a warship but a naval vessel built for surveying purposes in 1882. She was commanded by a number of well-known surveying officers, the most famous perhaps being Captain Henry Tizard, father of Sir Henry Tizard, the scientist. She spent the last 32 years of her life moored in the Thames below Gravesend as a sea school and she was broken up as recently as 1961.

The photograph shows her entering Whitby at the beginning of this century, a very handsome little vessel with her tall masts, figurehead and bowsprit.

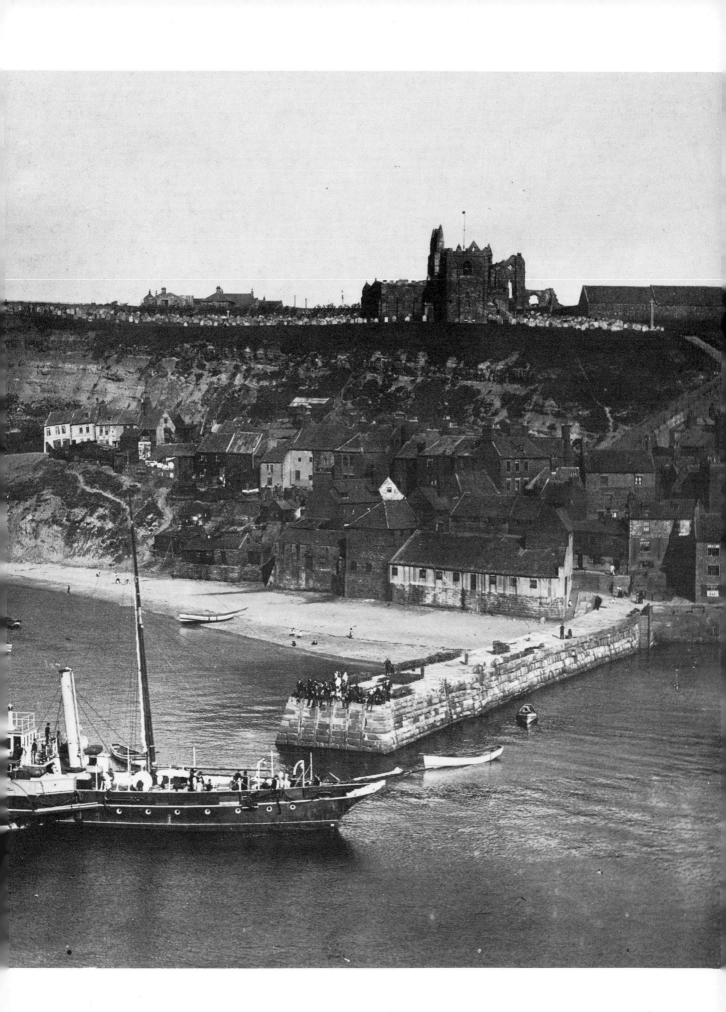

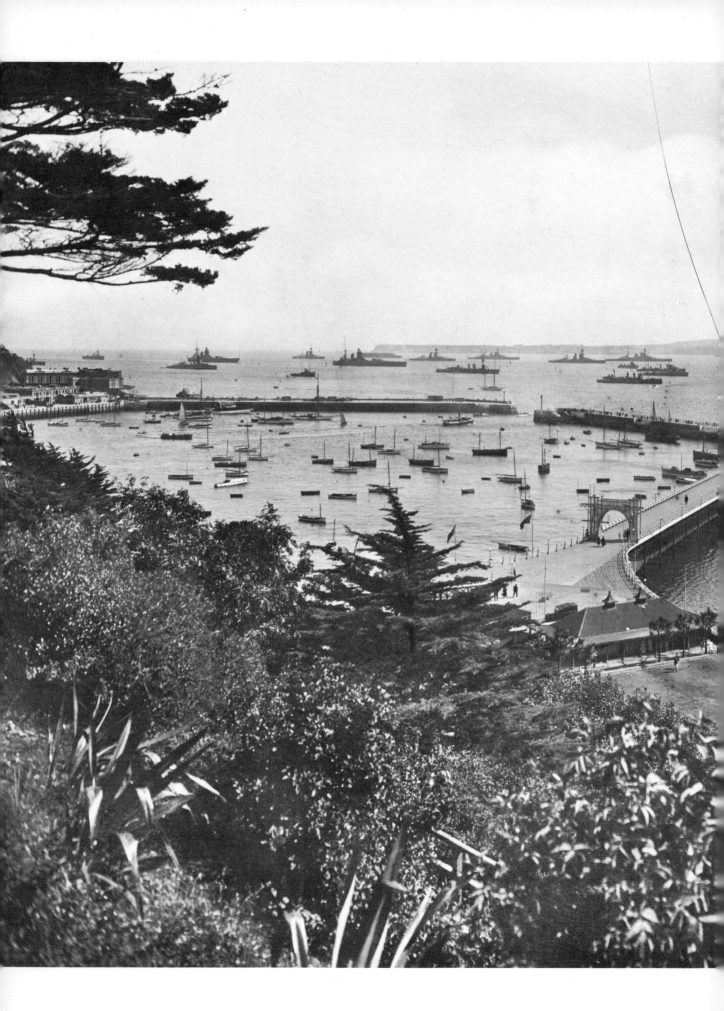

Plate 25

In fact, this photograph has no right to be in this book at all, but since it shows something which will never be seen again and which reflects the outcome of the naval changes and expansion of Queen Victoria's reign I have included it – the ships shown here are nearer to those of the 19th century than to the naval ships of today.

Unfortunately, the original negative has been scratched, but this does not spoil the impact of this fine photograph. It was taken in Torbay and shows the Home Fleet in the late 1920s and must be assumed to have been added to the album by the grandchildren of those who started it in the early 1880s. The ships visible include the *Nelson*, the *Rodney*, three of the Iron Duke class, the *Repulse*, the *Renown*, the *Furious* and the *Adventure*. There are also three C Class light cruisers and several destroyers, mostly of the V & W type, with two leaders.

This Navy seems almost as far away now as that of the *Pelorus*.

Section 4
PASSENGER STEAMERS

Francis Frith and Company do not seem to have taken portrait photographs of big merchant sailing ships, probably because they would not have made very readily saleable postcard subjects. The modern romantic interest in square-rigged sailing ships is a product of their total demise as normal working tools of man. When they were a real and prosperous part of the economic system they were less regarded than oil tankers are today.

Because of the advertising and publicity surrounding them, the crack liners of the period, like warships, were a different matter, and there are a number of superb photographs of liners of the 1870s and '80s in the collection. These were still the days of the single screw, when, partly because of the danger of dependence on a single means of propulsion, big steam vessels still carried a considerable area of canvas set from masts and yards even bigger, in some cases, than those of the huge steel four-masted barques which were their sailing ship contemporaries.

The habit of using sail died hard. Sail-trained masters and mates had acquired one of the most difficult of all skills and

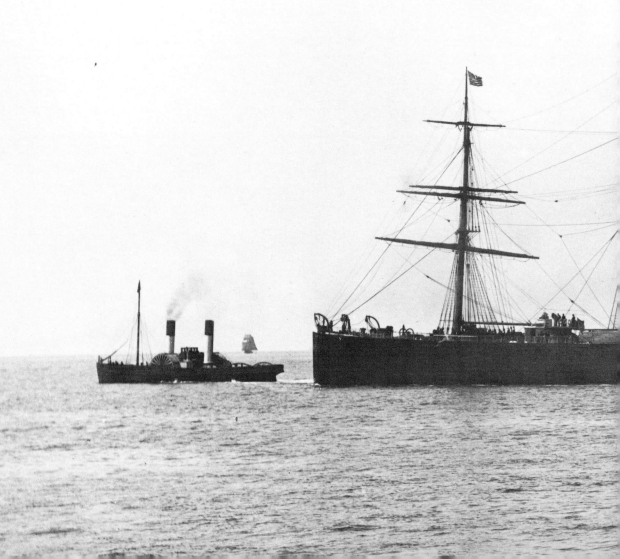

Plate 26

one which few were able to perfect. They naturally regarded the use of sail almost as a virtue in itself, though by the end of Queen Victoria's reign, except on very low-powered and special-purpose vessels, sail on steam ships was completely obsolete. But it lingered on until the First World War, and even after. I myself remember seeing a little Estonian steamer quite heavily rigged as a two-masted fore and aft schooner discharging cargo in Dover as late as 1939.

Besides the big passenger steamers Francis Frith and Company photographed smaller vessels not, usually, as objects of interest in themselves but as part of the local scene. Today, these photographs are as interesting to us as those of the big liners.

The *Spain* was one of a group of ships built for the National Line in 1870/71 and the photograph was taken in the 1880s. She was an iron-built compound-engined single-screw vessel with accommodation for 120 first-class passengers and numerous emigrants, together with cargo. One of her diversions was to act as a transport during the Zulu War of 1879. She ran between Liverpool and New York until 1890 when the National Line, then in decline, concentrated upon a London–New York service. She was of 4,500 tons gross and was sold for scrap in 1896.

Note the two-funnel paddle tug towing her out of the Mersey and the two-masted schooner running in and visible over the tug's stern. The *Spain* herself began with square sails like those of a contemporary sailing ship on her fore and main masts, and fore and aft sails on mizzen and jigger, but by the time this photograph was taken the yards had been stripped from her mainmast.

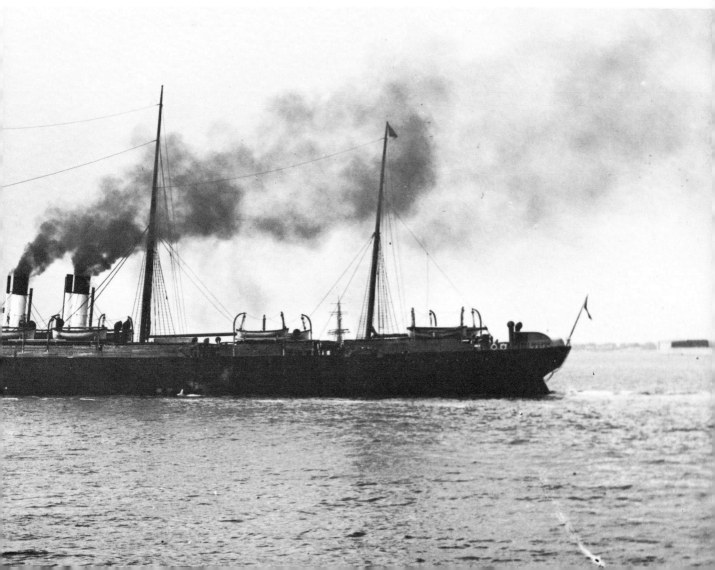

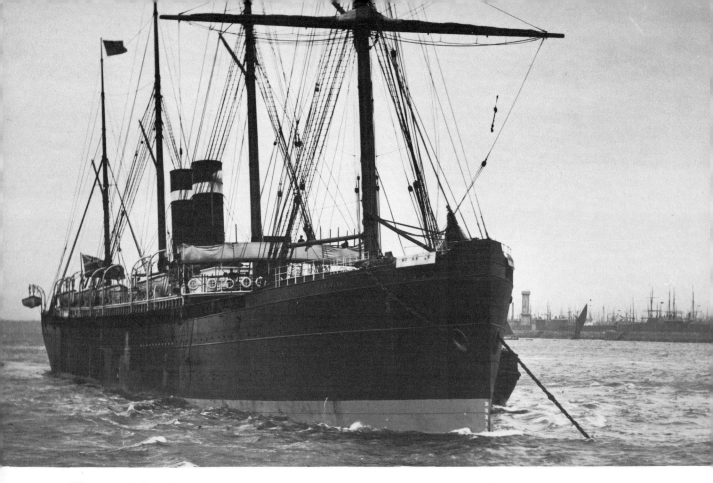

Plate 27 (Above)

Probably taken about the time of her maiden voyage this superb photograph shows the Allan liner *Parisian*, completed by R. Napier & Son in 1880, which ran for many years between Liverpool and Canada with great popularity and success. She is seen here lying at anchor in the Mersey. In fact, she was the first steel transatlantic liner and her compound engine gave her a speed of 14 knots. Of over 5,250 tons gross, she was rigged as an enormous four-masted topsail schooner. She served the Allan Line until she was sold to Italian scrap merchants in 1914 and one of her last acts was to pick up some of the survivors of the *Titanic*.

Notice the forest of masts in Liverpool docks and the completely open bridge from which this great liner was controlled.

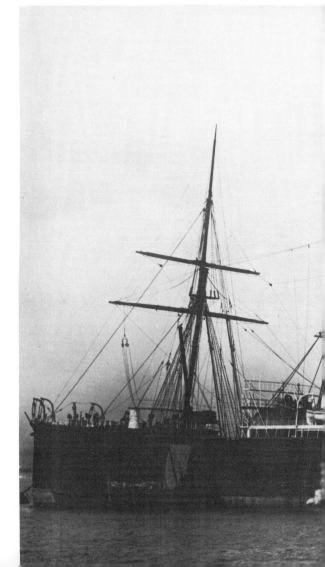

Plate 28 (Below)

The *Servia* was the largest Cunarder ever built when she was launched by J. & G. Thompson in 1881, though she was soon to be overshadowed by the *Etruria* and the *Umbria* of 1884/5. She ran all her life in the Liverpool–New York service until sold in 1901 for breaking up. The first steel Cunarder, she had electric light and was capable of a speed of 16 knots. Of 7,400 tons, she was over 500 feet long.

Note the steam cranes in the barges alongside which are in the process of loading her with parcels of cargo and passengers' baggage. The staging round her funnels was to enable men to paint them, and cargo and baggage handling gear is rigged on all her three masts.

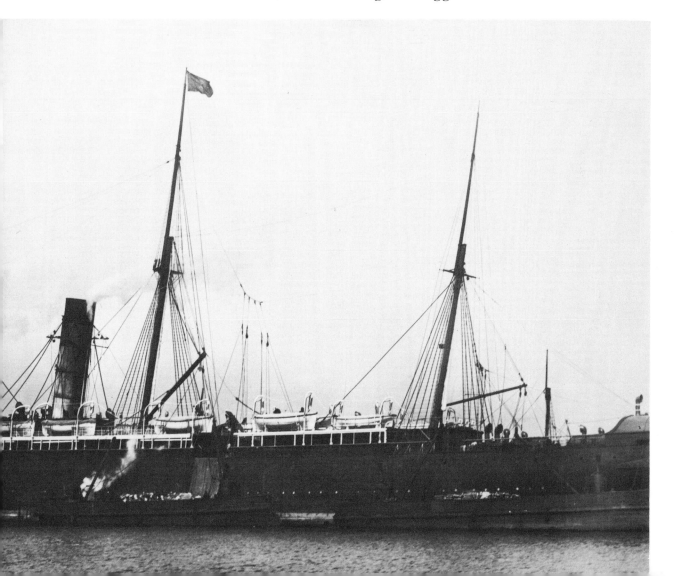

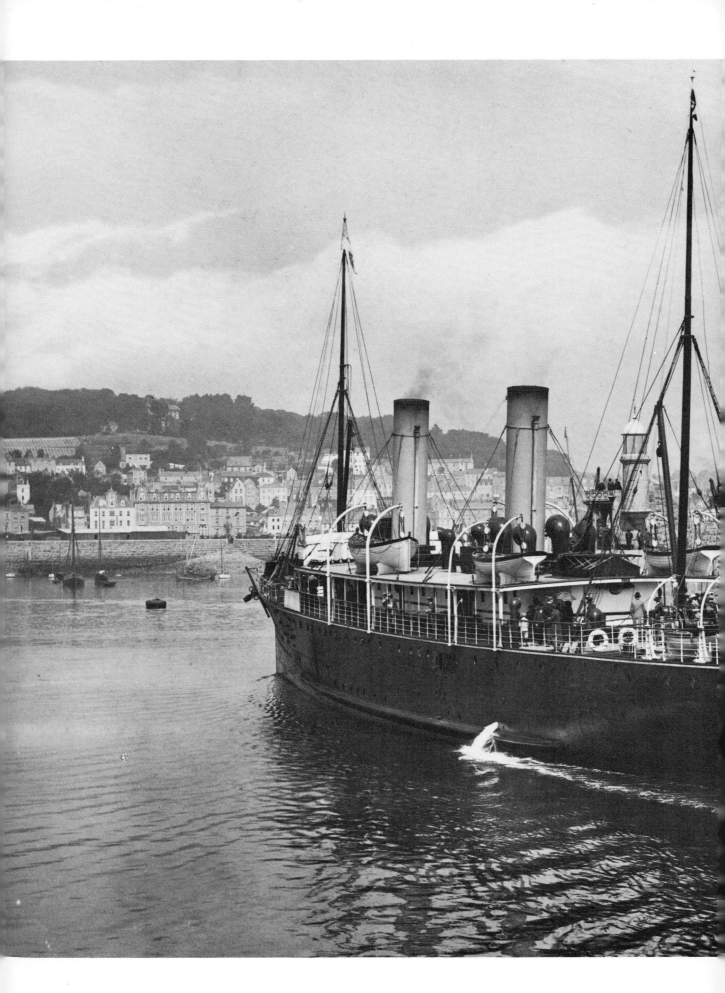

Plate 29

The channel steamer *Alma* was built on Clydebank for the London and South Western Railway Company in 1890. Although intended mainly for the Southampton–Le Havre overnight service she ran on occasions to the Channel Islands and in this photograph she is shown entering St Peter Port, Guernsey, probably around the turn of the century. Of 1,145 tons gross, she was sold in 1912 to an Algerian owner, and eventually to Japan where she was renamed the *Shokaku Maru No 2*. Notice that she has no sails.

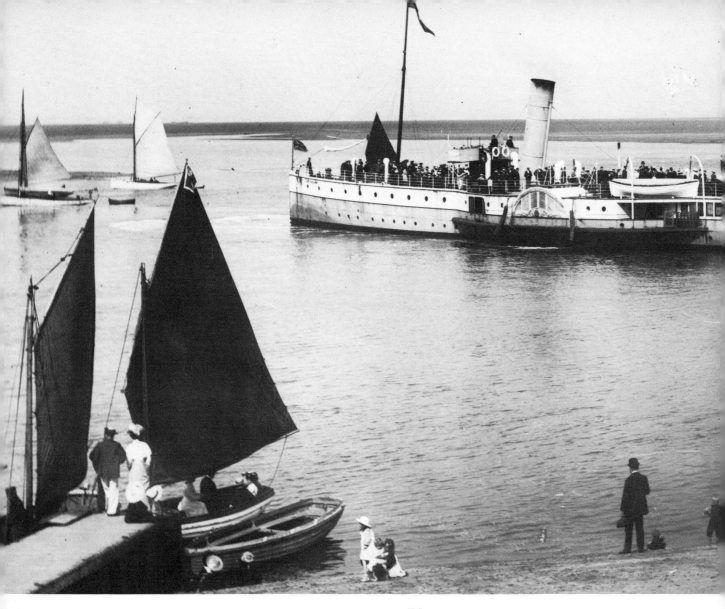

Plate 30 (Above)

Built in 1895 by Archibald MacMillan & Co for the Lady Margaret Steamship Company, the *Lady Margaret*, shown at Fleetwood, was almost at once transferred to P. & A. Campbell and used in the Bristol Channel passenger trade. In 1903, probably shortly before this photograph was taken, she was purchased by the Furness railway for a service from Barrow to Fleetwood and back. She ran in this service until 1908. Next year she was bought by the Admiralty who used her as a tender at Chatham, under the successive names of *Liberty*, *Wanderer* and *Warden*, until she was broken up in 1921.

Notice the passengers, including women, boarding the standing lug-rigged boat in the foreground and the Morecambe Bay prawners (see Plate 9) in the background to the left.

Plate 31 (Below)

he steamer leaving Llandudno is apparently the *Alexandra*, built by Caird & Co of Greenock in 1863, for the London Brighton & South Coast Railway's Newhaven–Dieppe service. After running on this route until 1884, she ran in the Bristol Channel for a few years, before changing over to the Liverpool and North Wales service of R. & D. Jones of Liverpool, during which time she had the after saloon built on. From 1892 to 1895 she returned to the Bristol Channel, running from Swansea for J. Jones before being sold to a south coast company to run in her original area of Hastings to Brighton. She was eventually broken up in 1905.

The photograph was taken at the end of the 1880s and the vessel appears to be approaching the west side of Little Orme's Head.

I have included the photograph because it is such a fine one. The vessel is turning away in a welter of foam. There appears to be a little sea running and the wind is off the land.

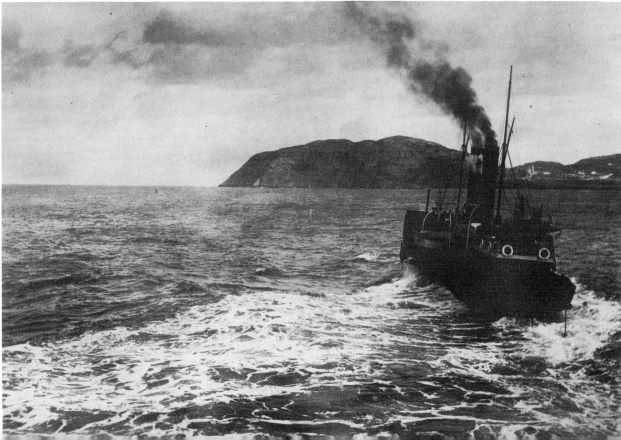

Plate 32

This is one of my favourite photographs. It shows the passenger steamer *Totnes Castle*, a vessel built by Philip of Dartmouth in 1894 for the service on the River Dart between Dartmouth and Totnes in which she ran for about 18 years. She is shown at Totnes soon after she was built, landing passengers, some of whom are embarking into a horse bus from one of the local hotels. Their luggage, including a massive trunk, has been loaded on top, and another horse-drawn vehicle is just driving away. Boats are being rowed on the river; the one in the right foreground is particularly noteworthy with its very typical group of two men and two women, all nicely turned out, the men in hard straw hats. A group of girls on the slipway are talking to a man in a kayak canoe, while a soldier, who appears to be enjoying the company of four young women, looks on.

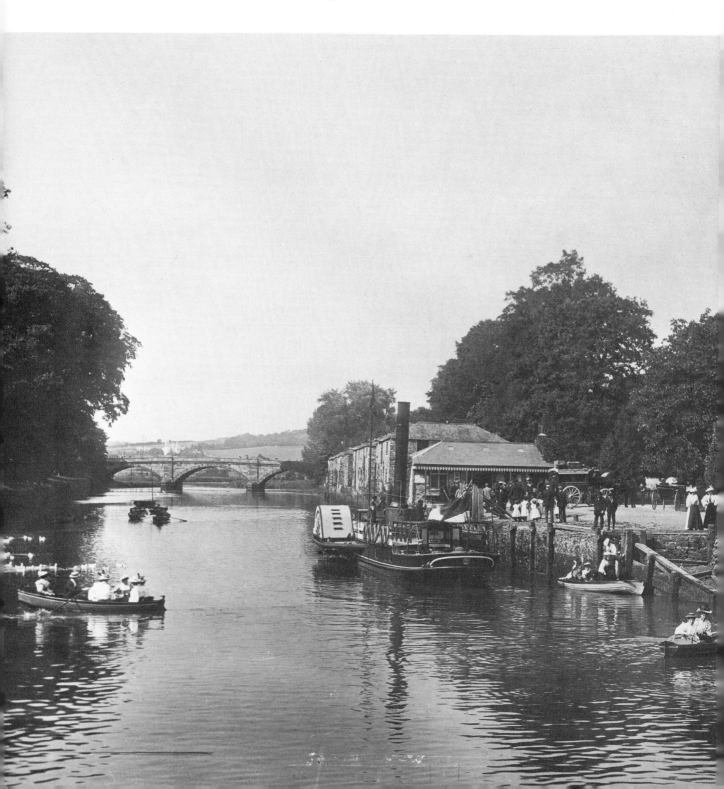

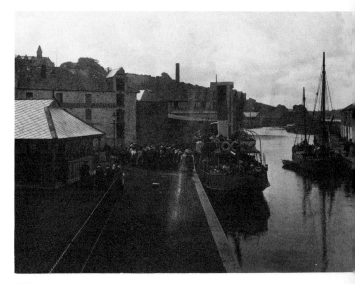

Plate 33

ere is another westcountry holiday crowd, this time in the process of embarking in a small passenger steamer – the *Princess Victoria* – at Truro, just before the First World War. The *Princess Victoria* of Truro was built at Falmouth in 1907 for service between these two towns. The trip is a very pleasant one indeed and when this photograph was taken, before the days of motor transport on the roads, the river and creek system between Truro and the sea was very busy with barge traffic and with small merchant ships. Two of the local river sailing barges can be seen discharging at the quay opposite the *Princess Victoria*. They are both light – river barges are very low when loaded with cargo. They were not subject to load line regulations because they were not registered unless they sailed outside certain limits which could include not only the whole of the Fal and its tributaries but also the Helford River.

Section 5
TUGS

The development of the big steam ship, like that of the big sailing ship in the late 19th century, was made possible by steam tugs (see Plate 26). These existed in a multitude of forms from the little river vessel, like that illustrated in Plate 34, to very large sea-going ships, some bigger than many cargo-carrying vessels. Tugs were both paddle and screw, and the paddle was retained for the tug long after it was abandoned for the cargo-carrying vessel. A splendid example of a paddle steam tug built before the First World War is to be seen on display at the National Maritime Museum in the New Neptune Hall, where you can go into the engine room, look into the master's accommodation and that of the crew, and walk her decks. In doing this you will be well in tradition, for, although the National Maritime Museum's *Reliant* was not used for passenger work, many steam tugs were, in those days of lax regulation of public transport, when they were not performing towage duties. Plate 50 shows the *Privateer*, a coastal passenger-carrying tug of the Bristol Channel, and the *Princess Victoria* in Plate 33 occasionally towed small vessels up the river.

Most of the tugs illustrated in this section carried passengers when their owners reckoned they could make a profit by doing so. If they had not done so they would not have been photographed by Frith. As it was, the passenger-carrying function made them good potential subjects for postcards. Though Francis Frith's idea was to show people enjoying themselves on the water, or a pleasant scene in which a tug was accidentally present, as in Plate 34, the resultant photographs give us useful illustrations of some classic tugs.

Plate 34

This is a quay just below Kingsbridge on the east bank of the river, a busy place particularly for discharging cargoes of stone. The photograph is full of points of interest. The schooner on the left, a vessel rigged with a topsail and a flying topgallant sail, has discharged her cargo and is being towed away from the berth by the little tug in the centre of the picture which is being given a marked list by the weight of the tow, pulling her over to starboard as she pulls the schooner's head round. This is a typical little river

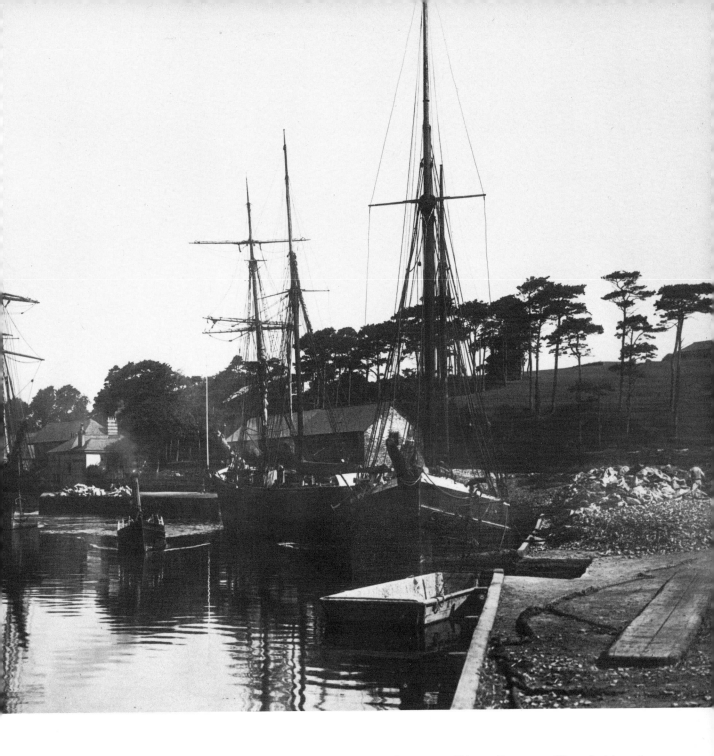

steam tug, and vessels of this type greatly facilitated trade to these up-river ports frequented by small merchant sailing vessels which were able to conduct a thriving trade.

On the port side of the tug is a brigantine, the *Robin*, built at Pesapebiac, Canada, in 1866. Stern to stern with her is a running bowsprit ketch with her port bower anchor hanging on a wooden cathead of a type which became obsolete by the end of the 19th century, ready to be dropped. From her general appearance this ketch is the *Effort*, one of three very similar vessels built by William Date at Kingsbridge in the 1880s. Another was the *Ann* (see Plate 77). The foredeck of the third of these vessels, the *Mizpah*, almost identical to the *Effort*, has been rebuilt in a gallery in the National Maritime Museum which illustrates the history of these small wooden merchant sailing ships of the late 19th century. There you can see what it would have been like to stand on the quay by the pile of stones in the photograph looking over the bulwarks at all the gear in a small sailing ship's bows.

Plate 35

French ketch from one of the small ports of Brittany is shown being towed into Cardiff West Dock by the tug boat *Norman*, a typical small harbour tug, well known in Cardiff.

The ketch is carrying a cargo of pit props and she is different in a number of details from her British contemporaries. She flies a flag at the mizzen mast head which denotes her arrival from a foreign country. A Campbell's passenger paddle steamer, crowded with people, is passing her on the port side, probably bound across the Bristol Channel.

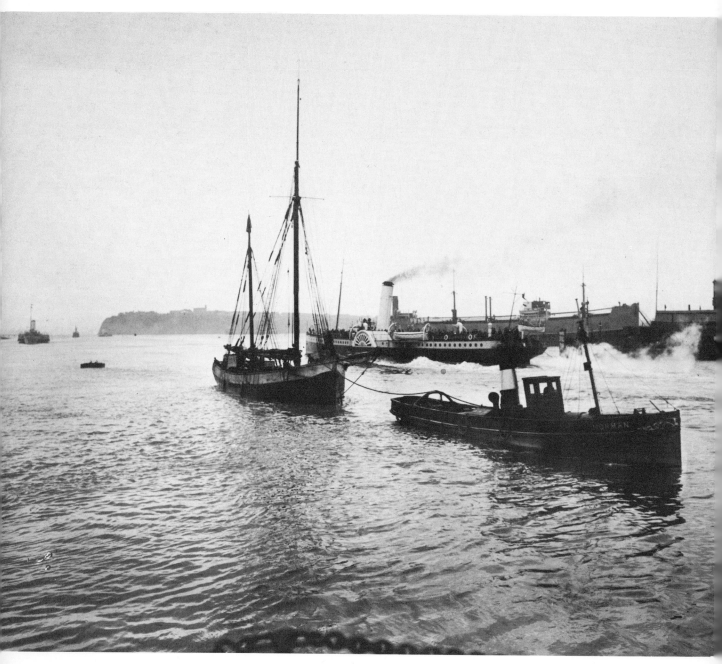

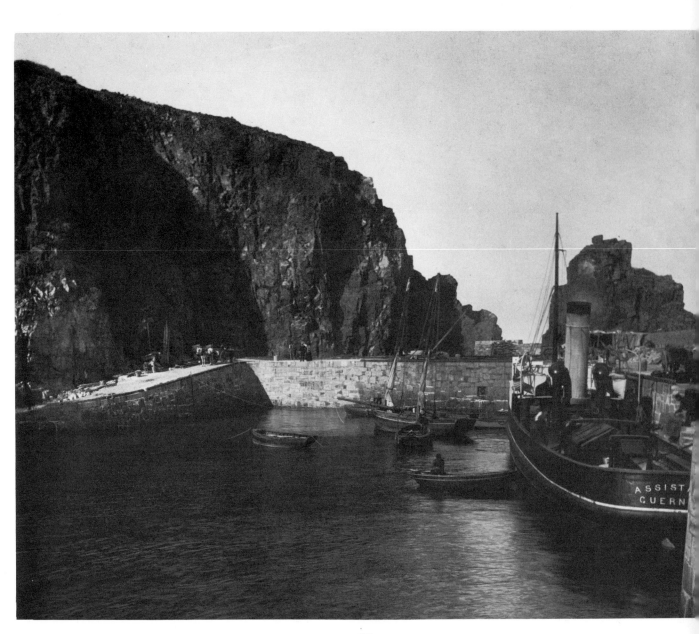

Plate 36

The steam tug *Assistance* was built at Paisley in 1886 for the Guernsey Steam Tug and Trading Company for towing and general work in the Channel Islands. Besides towing duties she carried passengers and luggage to the outlying islands and was used for excursions. She is shown here lying in the harbour at Sark in the 1890s, not long after she was built, and the luggage of passengers, in typical late-Victorian boxes and trunks, is being unloaded from a horse cart and passed down the steps to be received on board. Forward of her in the harbour lies a loftily rigged two-masted lugger of a type common in the Channel Islands at the time.

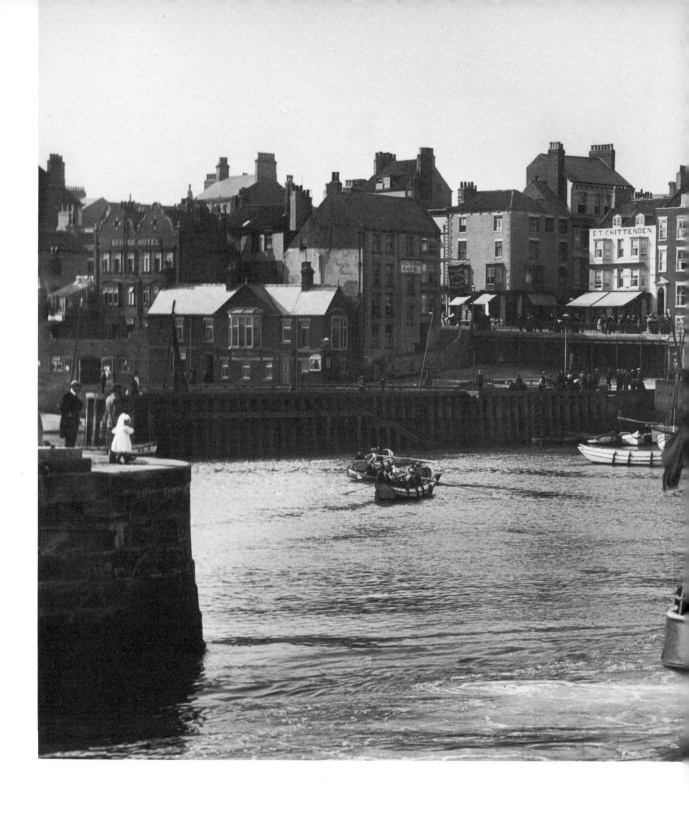

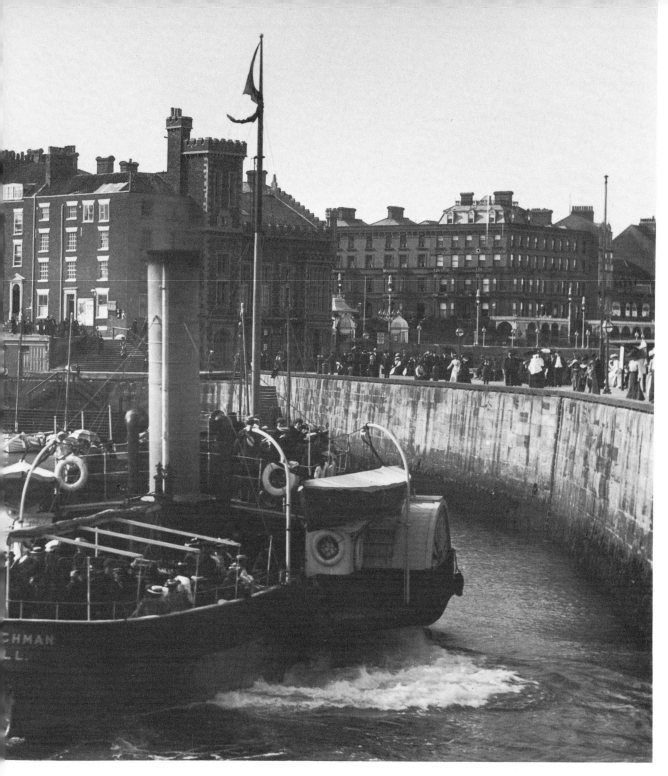

Plate 37

The handsome paddle tug *Frenchman* is here shown entering Bridlington Harbour in Yorkshire, where she was a very well-known and liked excursion vessel in summer. She was built by J. P. Reynoldson at South Shields in 1892 for H. Andrews of Newcastle and named *Coquet*. In 1899 she was sold and given the name shown in the photograph. She then began her summer excursion work out of Bridlington –

a very popular service which paid so well that in 1906 she was lengthened by 10 feet to give her more passenger-carrying capacity.

This photograph should be compared with that in Plate 1 which shows the same scene from the landward end of the same quay with another passenger-carrying tug loading her freight of passengers.

Plate 38 (Below)

Some paddle tugs were clinker-built of wood, that is, with the planks overlapping one another like the planks of many wooden boats used to be before the days of glass-reinforced plastic. Some small high-quality yachts' tenders and Norwegian fishing boats are still built this way today.

This was, of course, a very ancient way of building a boat and it dates back in northern Europe at least 1,500 years. The wooden paddle tugs were the last big vessels to be built in this way and, as such, are of some importance in the history of shipbuilding.

The *Boston* was one of them, built at South Shields in 1875 for the Boston Steam Tug Company. She is seen here at Boston in Lincolnshire (the top of the Boston Stump can be seen behind the trees in the background) with a very jolly looking party on board – again on excursion work which is no doubt why the photograph was taken. Some of the party are on the bridge which is a true bridge, like those of the first steamships, that is, a bridge across the vessel from paddle box to paddle box and used for conning the vessel rather than actually steering it. The steering position in early steamers was right aft – initially the steering was done with a tiller. Here it is just forward of the bridge on the main deck and, of course, the steering is done with a wheel.

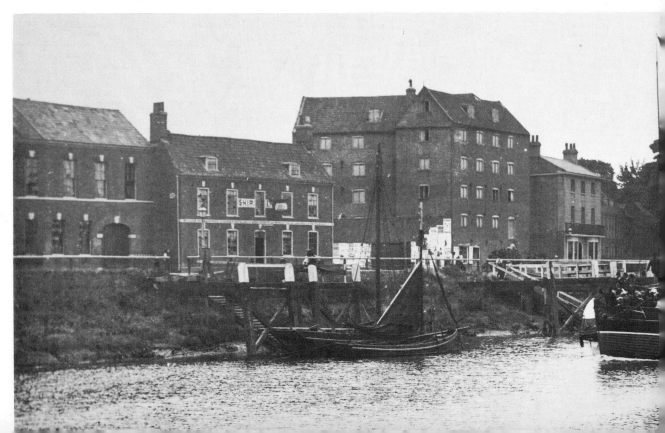

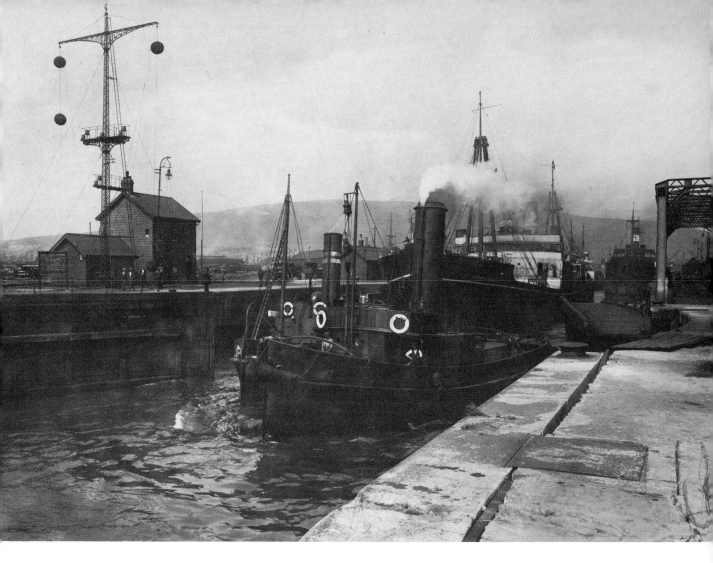

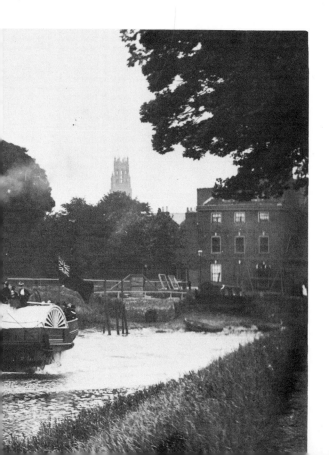

Plate 39 (*Above*)

By way of contrast this very late Francis Frith photograph – it was taken in the 1930s – was intended to show tugs at work as tugs. The tugs bringing the *Kepwickhall* (built at West Hartlepool in 1932) into Swansea are the principal subject of this photograph which, although so late, demonstrates all Frith's skill of composition. Notice, for instance, that the tug nearest the camera is in the very act of blowing her steam whistle, no doubt to give a signal to the tow. Unfortunately this tug, which appears in a number of photographs of Swansea taken at this period, has no marks by which she can be identified – not even her name or number on her lifebelts – a most unusual situation. She cannot have been registered and lack of documentation would make it extremely difficult to find out anything about her, but she is evidently not a new vessel and her general appearance is that of the medium-sized steam tugs of the 1890s.

Section 6

BIG PORTS & THEIR DOCKS

It must be remembered that the Frith Collection was compiled largely as the raw material for a great picture postcard library, and inevitably the staff photographed those places and scenes which would be most likely to sell as picture postcards. It might be expected that these would not include industrial areas, and yet there is a surprising number of photographs of big ports and dock systems.

I have selected a few of these, choosing them particularly where they show items of especial interest, or where even bigger changes than usual have since taken place. The most significant change, of course, is that these photographs show the dock systems filled with sailing vessels, from large square-rigged ships to local barges, coal burning steam ships and paddle vessels, completely different shipping from that which uses them today.

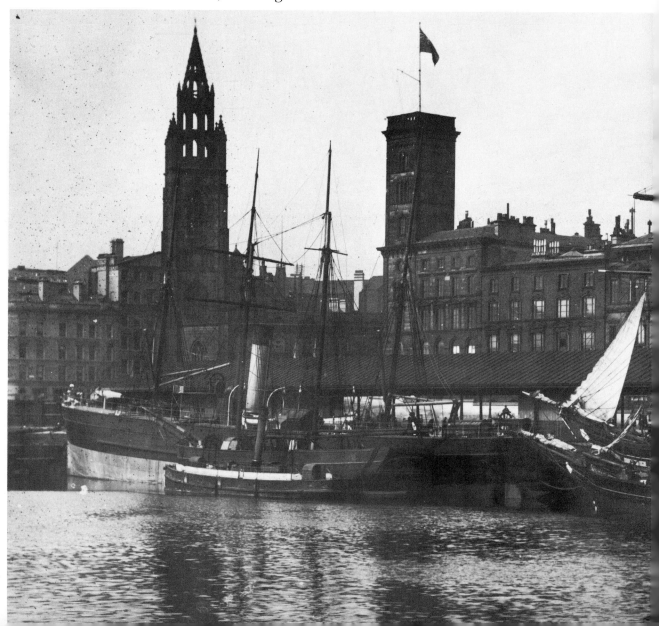

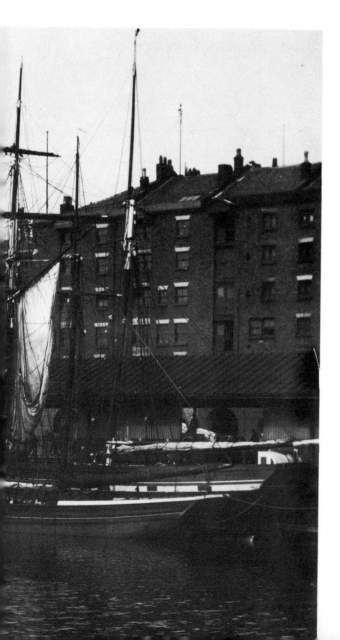

Plate 40

This is the fourth oldest photograph in the book, and shows St George's Dock, Liverpool. It was taken in the early 1880s or perhaps the late 1870s. It shows the two-masted schooner *Vine* of Belfast, a real old-timer, built in Yarmouth, Nova Scotia, in 1846, with bluff bows and heavy stern. The very smart little two-masted schooner astern of her with the big white figurehead is a great contrast. Between her and the dock wall is a big vessel with all the appearance of another Canadian-built schooner, perhaps one built in Prince Edward Island, a great centre of Canadian building of vessels for sale in Britain. She is very smartly kept up, and her jibboom, like those of the other sailing vessels, is rigged in. This was evidently a requirement in St George's Dock at the time for reasons of space and because of this the royal yard with which this schooner was evidently fitted has been sent down on deck. She is unusual in having a standing gaff foresail which has been hauled out along the gaff to dry. The boom jib has also been partly hoisted to dry.

Plate 41 (*Below*)

Inside the Alexandra Dock at Hull when this photograph was taken in about 1903 a large steam vessel was discharging through chutes into a barge, astern of which lay a Humber keel, the local type of sailing barge which even at this late date was still operated under a single square sail with lee boards. Lying light further up the dock was the big coal-burning triple expansion-engined steamer *Dido* of Hull, built there in 1896. She, too, appears to have been discharging into barges through chutes like the vessel in the foreground, but in her case discharging seems to be almost complete and only one chute, to the after hatch, is still rigged.

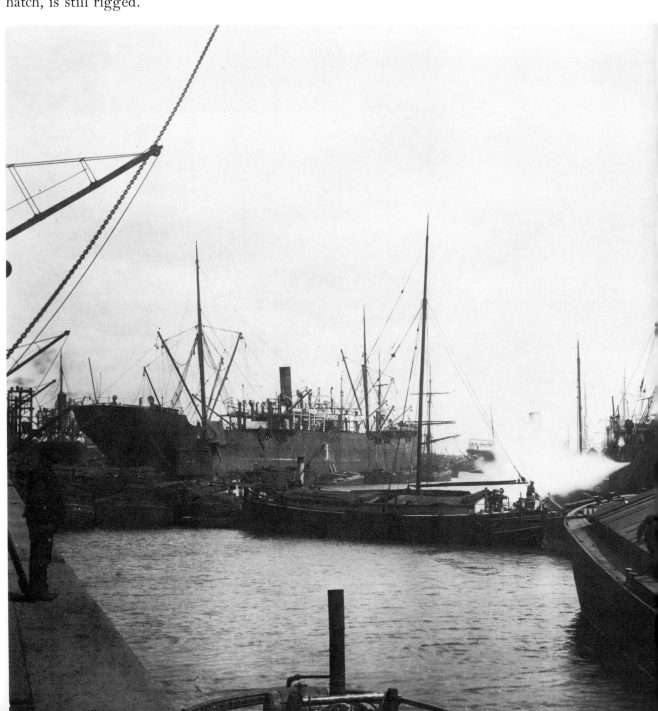

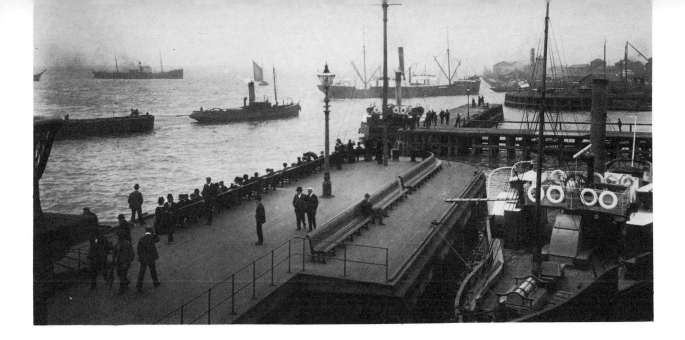

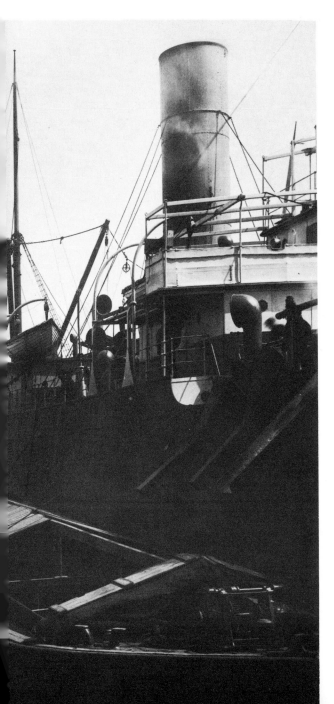

Plate 42 (Above)

Also taken at Hull at the same time as the last plate, this photograph shows the local ferry steamer *Atalanta* in the immediate foreground to the right, a steam tug bringing up barges, a large steam vessel behind a steam tug entering the dock, a Humber sloop, a fore and aft rigged version of the Humber keel, coming down, and other vessels both steam and sail lying off, presumably waiting to enter. There are plenty of spectators to watch the shipping on what was evidently quite a warm day, despite the overcast appearance of the weather.

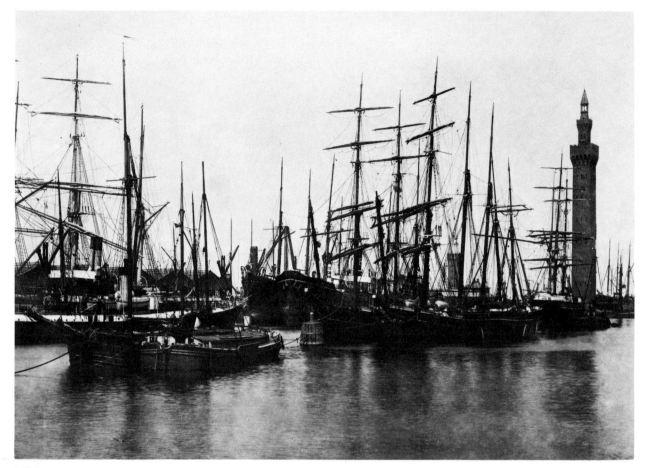

Plate 43

A fascinating variety of shipping is shown in this photograph of Grimsby in the 1890s. Right in the foreground are two splendid examples of local variations of the sailing barge. Nearest the camera is a Humber keel, like that in Plate 41, rigged with a single square sail with big lee boards to enable her to make some sort of a showing to windward. Alongside her is a ketch-rigged Yorkshire billieboy, a development on the same theme as the keel for coasting work outside the estuary. This one is named the *Tiger*. Among the steam vessels are the Norwegian *Skjold*, built at Gothenburg in 1882, and the *Napier*. The three-masted barque with her jibboom rigged in, apparently laid up, is the *Warden Law* and the three-masted barquentine alongside her the *Violet*. The *Warden Law* was built in 1871 at Sunderland and owned in Norway when the photograph was taken, and the *Violet* was registered at Bristol. The two-masted schooner lying alongside the *Violet* is the *Pride of Anglesey*, registered in Beaumaris. She was built at Barnstaple in 1859.

Plate 44

Of particular interest is this view of the Pomona Dock at Manchester because it demonstrates the way in which sailing ships had to strike their topmasts, that is, lower them, in order to get under Runcorn Bridge on the Manchester Ship Canal.

The sailing ship here is the three-masted schooner *Trevellas* and on her stern she has painted 'St Agnes, Port of Hayle'. This was because she worked out of the little Cornish harbour of St Agnes – later totally destroyed by the sea – but had to be registered at Hayle in the area of which port St Agnes lay. She was lost at sea in 1930.

The *Trevellas* has brought china clay to Manchester, probably from Charlestown (Plate 89) or Fowey (Plate 90) and she has discharged at least the last part of it into canal narrow boats, one of which is still lying alongside her, covered, like the port side of the vessel, with the fine white powder of the clay. This then is the other end of a classic 19th-century cargo passage that began in rural Cornwall and ended in industrial Lancashire.

The handsome steamer on the other side of the dock is named the *Thistle*.

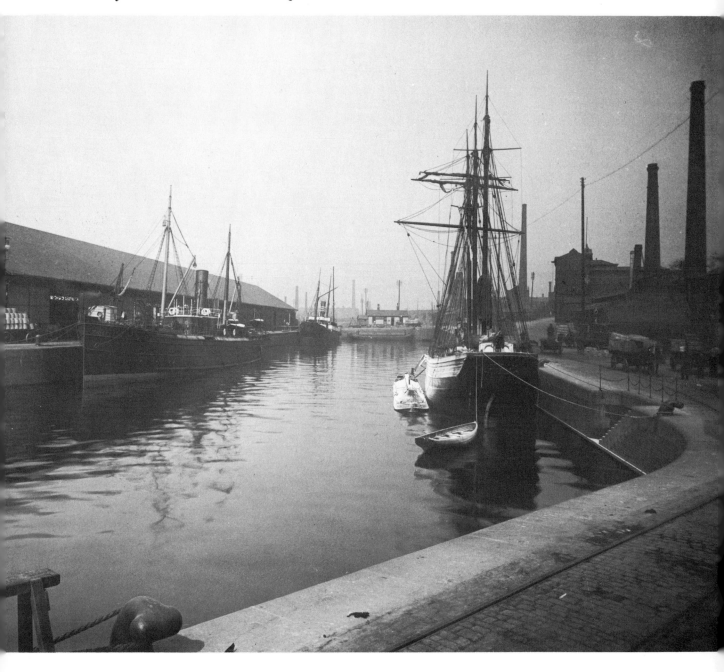

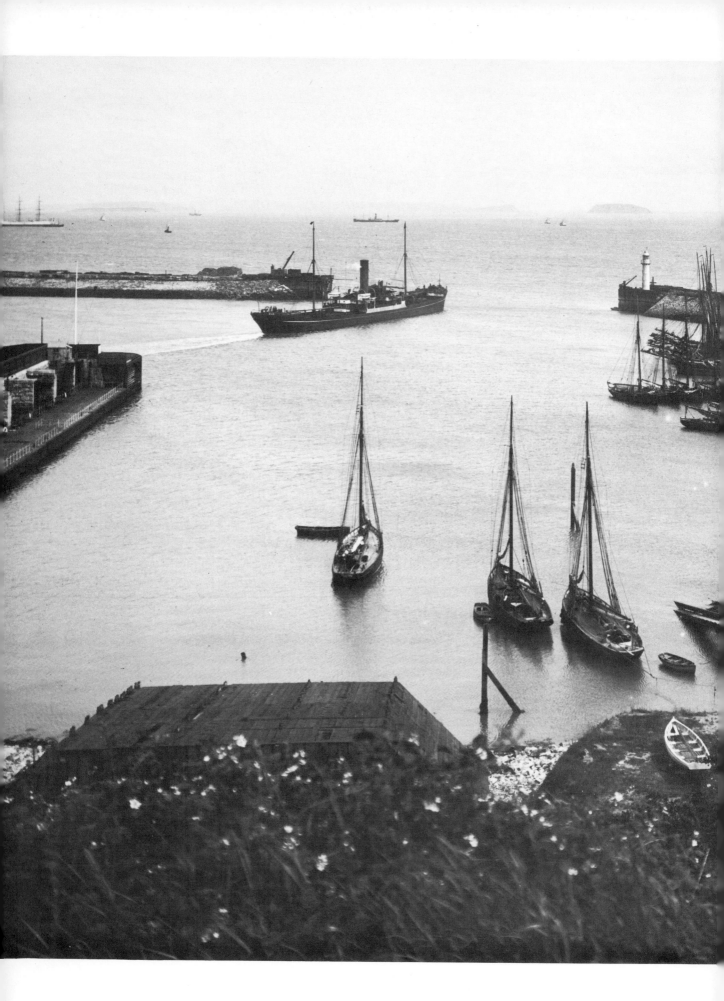

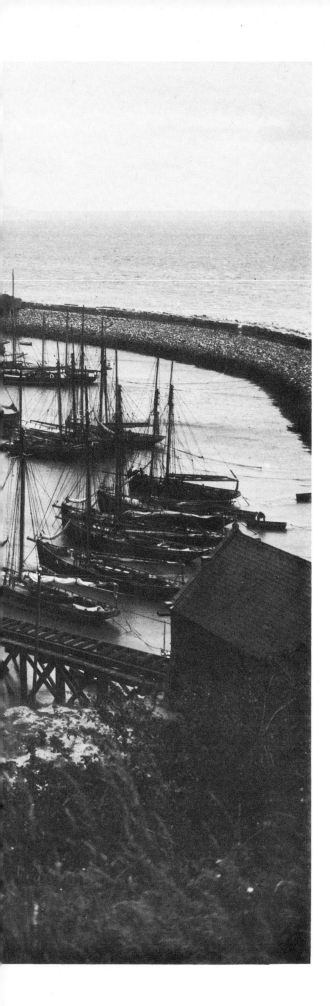

Plate 45

This is the entrance to Barry dock in South Wales. It was a favourite sheltering place for local Bristol Channel trading vessels. The Barry dock authorities provided chains on the breakwater on the right-hand side of the picture so that the vessels could drop their anchors and haul in close to the breakwater, stern first, and lie safely moored out of the way in all winds and weather. No dues were ever charged for this facility.

The photograph shows numerous ketches, probably many of them from Appledore across the Bristol Channel (Plate 86) and Bristol Channel pilot cutters moored in this way on the right-hand side. The ketches lie together, nearest the dock entrance, and there are about ten of them stern first to the breakwater. The pilot cutters are between them and the back of the harbour nearest the photographer.

Flat Holm and Steep Holm Islands can be seen out in the Bristol Channel with the Mendip Hills behind. A large barque lies out in Barry Roads, probably waiting for orders to discharge her cargo or for a fair wind out of the Bristol Channel. I remember lying here in the four-masted barque *Viking* as late as 1937 waiting for a wind to get out into the Atlantic. A big steamer is making her way out between the breakwaters.

FISHING PLACES & FISHING PEOPLE

Francis Frith and Company were photographing right through the great era of the sail and oar fishery in Britain.

In the early 1800s the small population and poor communications meant that commercial fishing was still conducted as a series of small local industries, their markets confined to the immediate neighbourhoods of the fishing harbours, except for salted and smoked fish which were sold more widely in England and exported abroad. Nearly all fishing vessels were small open boats.

But as the century advanced and the population increased and communications improved the industry changed out of recognition. Great fleets of sailing fishing vessels grew up. The vessels themselves became larger and larger and eventually in the later years of the century the steam trawler and the steam drifter became firmly established, though not to the exclusion of the sailing fishery, which lingered on in some places until after the First World War. At the same time the number of smaller fishing boats greatly increased until every beach, creek and river had its little fleet and most seaside communities derived some of their income from fishing.

But even with this relative prosperity few fishermen could hope to better themselves and the life in all sections of the industry was extremely hard. While a small cargo-carrying sailing vessel could be the basis of a little fortune for an industrious and lucky shareholding family who worked her themselves, very few fishermen could ever hope to build up capital in this way. It was a hand-to-mouth existence, arduous, uncertain and by modern standards impoverished.

The group of photographs which follows shows the huge size of the sailing fleets of the late 19th century and some of the harbours from which they operated. They show the beach boats and the fishing villages, and were taken as the raw material for picture postcards. However, they show also the people, the men and women who depended on the sail and oar fishery for their livelihoods, and here, whether it was intended or not, Frith's photographs are a particularly vivid historical record and at the same time an implicit social commentary. Here is evidence of the ruggedness of a life in which to drop behind was probably to fall for ever.

Plate 46

The first photograph in this section was taken at Brixham in South Devon, a harbour which played a very important part in the development of the fishing industry in Britain. Vessels from Brixham were employed in a long-range fishery working on the North Sea banks as far back as the 1500s. In the 18th century the harbour facilities were greatly extended and immediately after the Napoleonic Wars Brixham vessels were working all the way around the coasts of England. In the 19th century there was, of course, great development and Brixham men migrated to establish the trawl fishing industry at many of what were later to become the big North Sea fishing ports.

More's the pity that a comprehensive history of the Brixham fishery has not yet been written. Though it was on a scale comparable with the much-publicised sailing fishery conducted out of Gloster, Massa-

chusetts, in the United States and featured in Kipling's *Captains Courageous* and numerous American books, there is as yet no adequate study of the Brixham sail fishery.

This photograph shows a group of the last and largest Brixham sailing trawlers lying in the outer harbour on a calm morning, each mirrored on the slightly rippled surface of the sea. Notice that they are beam trawlers, that is, the mouth of the trawl net was held open by a long wooden beam, clearly visible on the port side of the nearest vessel. Modern trawls, towed at a higher speed by high-powered motor vessels, are kept open by the pressure of the water on fins mounted at the mouth of the net.

The vessels shown here are ketch rigged, with two masts of uneven height, the after one the shorter, and represent the British sailing fishing vessel at her finest.

Plate 47

Brixham vessels fished anywhere between the North Sea and the Irish Sea, and in the summer large fleets of them based themselves at harbours far away from their home port. One of these harbours was Tenby in Pembrokeshire, and this photograph shows a fleet of Brixham trawlers drying their nets on a summer's day in Tenby and there are more trawlers anchored outside the breakwater. The photograph was taken before 1902, for in that year the prefix to the number painted on the vessel's bows, DH for Dartmouth, was replaced by BM for Brixham. It was, in fact, probably taken in the 1880s for, while many of these vessels are smack rigged, that is, single masted, there are a few ketches amongst them and it was in the '70s that the big ketch like those depicted in Plate 46 which became the classic first-class Brixham fishing vessel, began to come into use. These new vessels could develop the sailing power to drag the big trawl which made for efficient fishing to meet a growing market. The date suggested above is supported by the serial number of the photograph.

Besides the trawlers there are a number of smaller vessels, some of them with the M registration which shows that they were Mumbles oyster skiffs. There was a prosperous oyster fishing industry out of Tenby in the last century and an oyster dredge is clearly visible lying on the stones of the little quay in the foreground. The vessel with her sails set to dry is a trading ketch, a cargo-carrying vessel, and from her general appearance she was quite old when the photograph was taken. She was probably built as a smack and converted into a ketch with a smaller mainsail in order to make her easier to handle. A section of starboard bulwarks has been removed in order to enable her to discharge her cargo. Her name appears to be *Ann* and she may be a vessel of that name built at Dartmouth in 1805 and, at the time the photograph was taken, owned in Bridgwater.

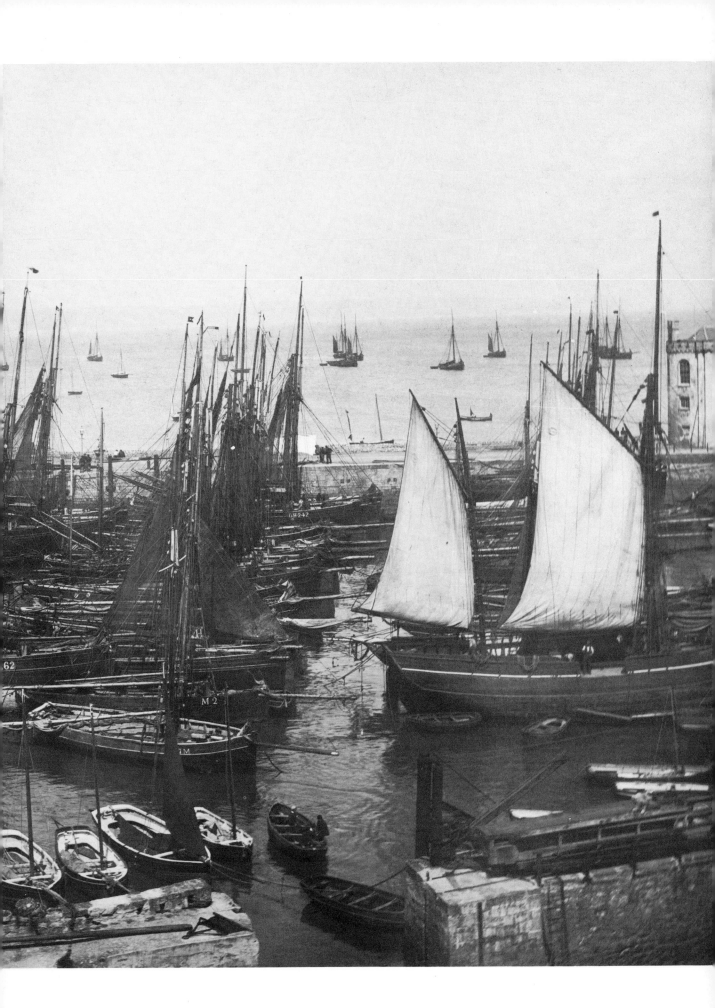

Plate 48

At the mouth of Tenby harbour three Brixham trawlers, two ketches and a smack, are lying aground at low tide. Members of the crew are working on the hull of the nearest ketch, DH 270; they are probably looking for a leak, while the boy leans over the starboard bow. From the way they heel over when they take the ground at low tide it can be seen how sharp these vessels were, with hulls much finer in shape than most of the small sailing trading vessels which are illustrated later in this volume. The sailing fishermen carried light small cargoes of fish and they had to develop the sailing power and speed to pull the big trawl. The cargo vessel's

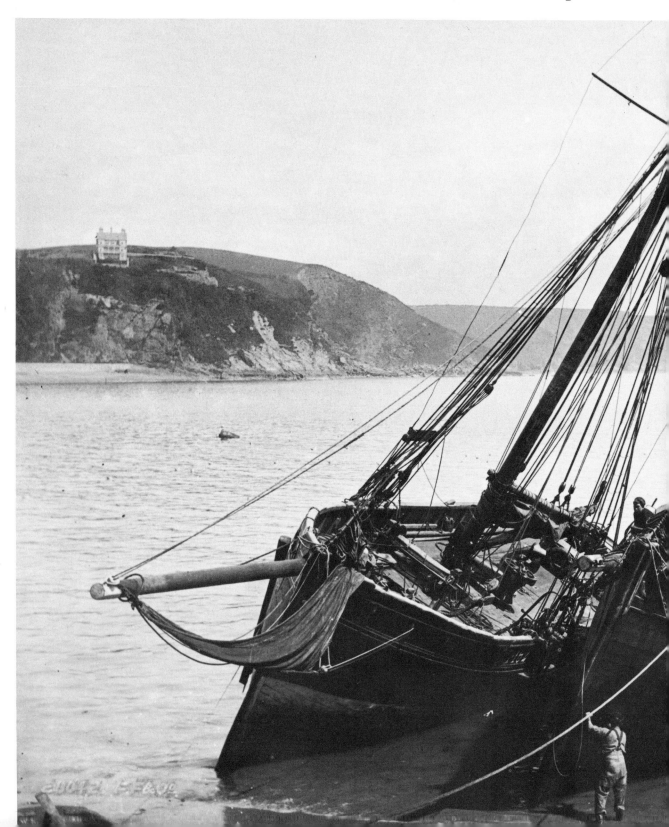

function was to carry the maximum economical cargo and lie upright aground in harbour at low tide with a heavy cargo in her without being damaged.

This photograph shows a good deal of the vessels' gear: the big trawl nets, particularly on DH 270, with the beam with the iron work at either end, and the capstans used for hauling in the trawl. The development of these capstans, latterly driven by steam, in place of the horizontal handwindlasses previously used, reduced the time necessary to pull in the trawls from several hours to a matter of 20 or 30 minutes and enormously improved the efficiency of the industry.

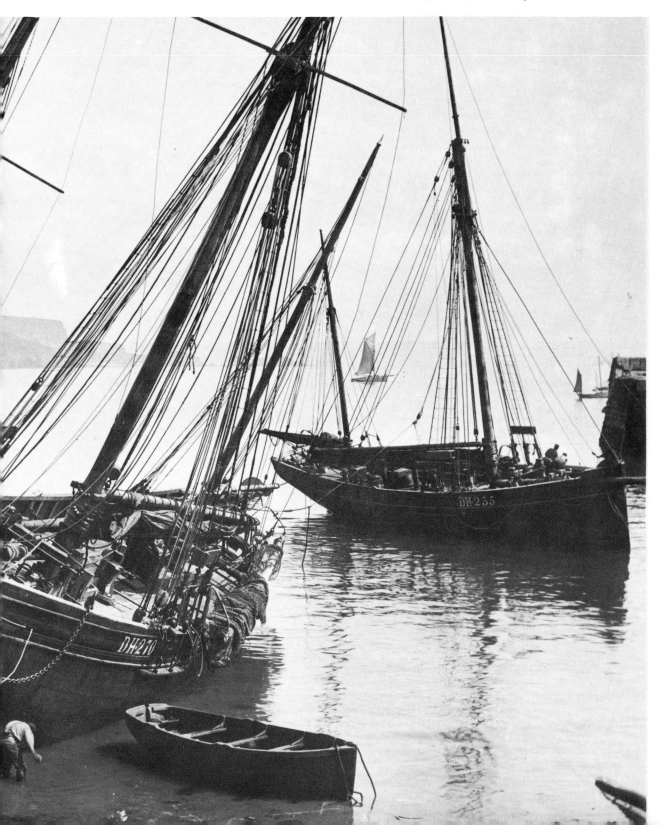

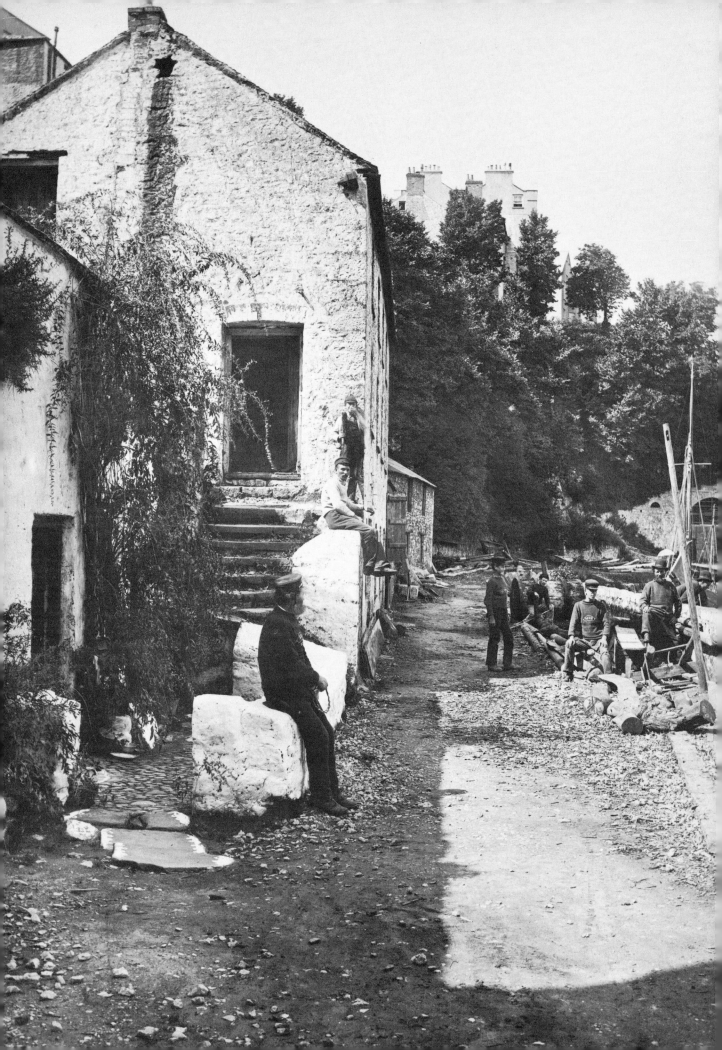

Plate 49 (Left)

Plate 50 (Below)

The crews of the Brixham trawlers used to bring their wives and families over to Tenby for the summer. Some of them settled there, and there are people in Tenby today who can trace a Brixham ancestry. This view shows cottages in the harbour area and the grouping of the figures on the right-hand side of the picture suggests that they have been posed. It was Frith's custom, and that of his subordinates, to arrange posed groups of this kind on occasion. Although now we think of this kind of photography as rather artificial, in fact this posing is a part of the formal composition of the picture and adds to the pleasure we nowadays derive from it, quite apart from the fact that it contributes to the value of the historical record.

Notice that a number of these men and lads are wearing jerseys with the names of the smacks in which they work embroidered on them. The bowler hat is still customary for the older men and the peaked seaman's cap for the younger. In the background, behind the group on the right-hand side of the picture, is what appears to be the stump of a great mast, built up from a number of timbers bound together with iron bands. The full-size mast cannot have been much smaller than the huge fore lower mast of the *Great Britain*, now on display at the National Maritime Museum.

This group of Brixham trawlers, ketches and smacks outside Tenby is probably waiting for the tide before entering the harbour. The smacks are typical of the second-class Brixham vessels of the period – the 1880s – and were known as 'Mumble Bees' from the fact that many of them were employed in this Tenby-based fishery operating off nearby Mumbles.

During the summer season, when some of the Brixham boats worked out of Tenby alongside the local sailing trawlers, the crews used to break their stay, if they had not brought their families with them, by crossing to Ilfracombe, either in their own vessels or by pleasure steamer, and making the journey home to Brixham by rail. It could be that this photograph was taken on a Saturday, for no fishing was done on Sunday by Brixham men and if possible they would get back to the harbour from which they were working by Saturday night.

The tug *Privateer* lying in the foreground was built at Newcastle in 1883 and from that year until 1895 ran excursions with passengers from Bideford to Tenby in the summer months. She left Bideford Quay at 8.30 am when the tide permitted and returned the same evening. The first-class fare was 5s (25p) and entitled the passenger to access to the bridge – something which would not be allowed today for reasons of safety.

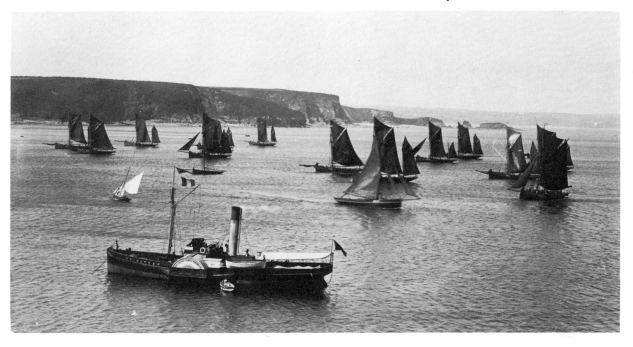

Plate 51 (Below)

his magnificent photograph, taken in an east coast port, shows a vast fleet of sailing trawlers and a few steam vessels, including the tug in the foreground. Once again, Brixham vessels are present (DH 168 is clearly visible behind the tug) in a port which had developed its fishing industry partly as a result of their pioneering efforts but which, by the time the photograph was taken, had greatly outstripped Brixham in size and scale of operation.

The two vessels in the immediate foreground, the *Judith* and the *Mary Ann*, have their bowsprits rigged in order that they shall not take up too much room in the congested harbour. The fishermen in the open boats in the foreground are wearing the old stiff oilskin sou'westers which are still in use in Nova Scotia in the mid-1970s. They were made by soaking cotton fabric in linseed oil, perhaps coloured with boot blacking, and allowing it to oxidise and dry out, when it turned stiff. Like oilskin jackets made in the same way they were never very satisfactory and needed constant attention and reproofing. But permanently proofed oilskins were not readily available in this country at prices that fishermen could afford until well into this century.

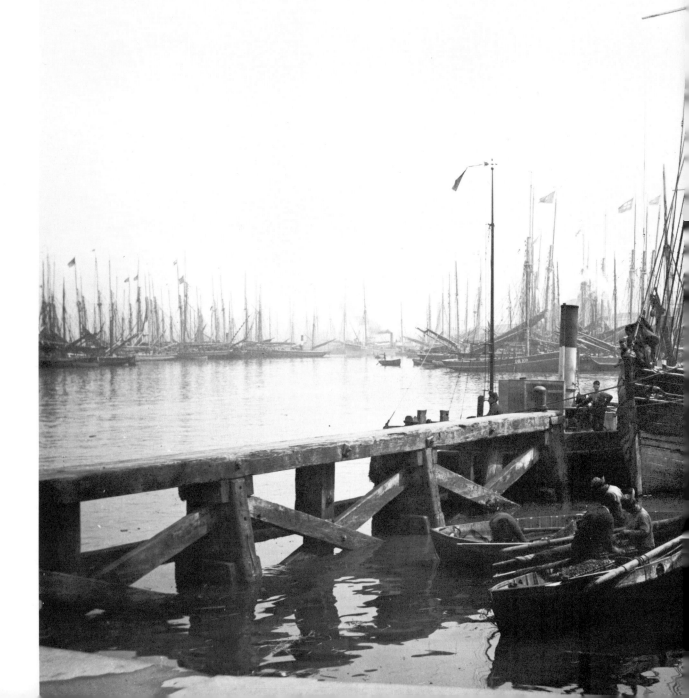

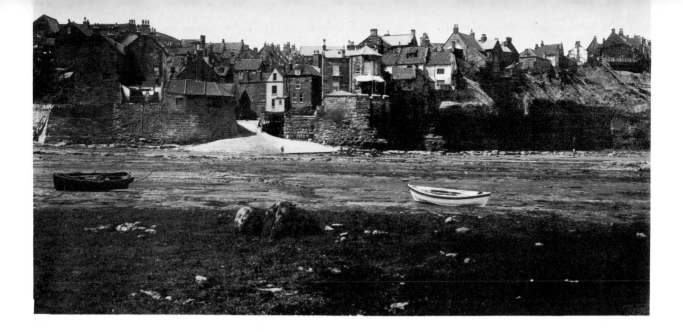

Plate 52 (Above)

I have included this photograph of Robin Hood's town near Whitby in Yorkshire because of its limpid quality. Notice the clarity of the detail, both in the foreground and in the stones of the cliffs and the walls that continue the line of the cliff on each side of the ramp leading down to the beach. The huddle of houses, each with its sewage pipes leading straight out over the cliff on to the beach, the huddle of boats on the top of the ramp, and the washing drying in the gardens, are all revealing of the social background to this beautifully composed picture.

The sky is blank. The early photographers were all faced with the difficulty that the emulsions they used were not sufficiently sensitive to colour to record cloud effects, even with the use of filters. The photographer therefore had to accept either a blank sky, as in this case, or to adopt a degree of faking, which was sometimes successful but usually better avoided.

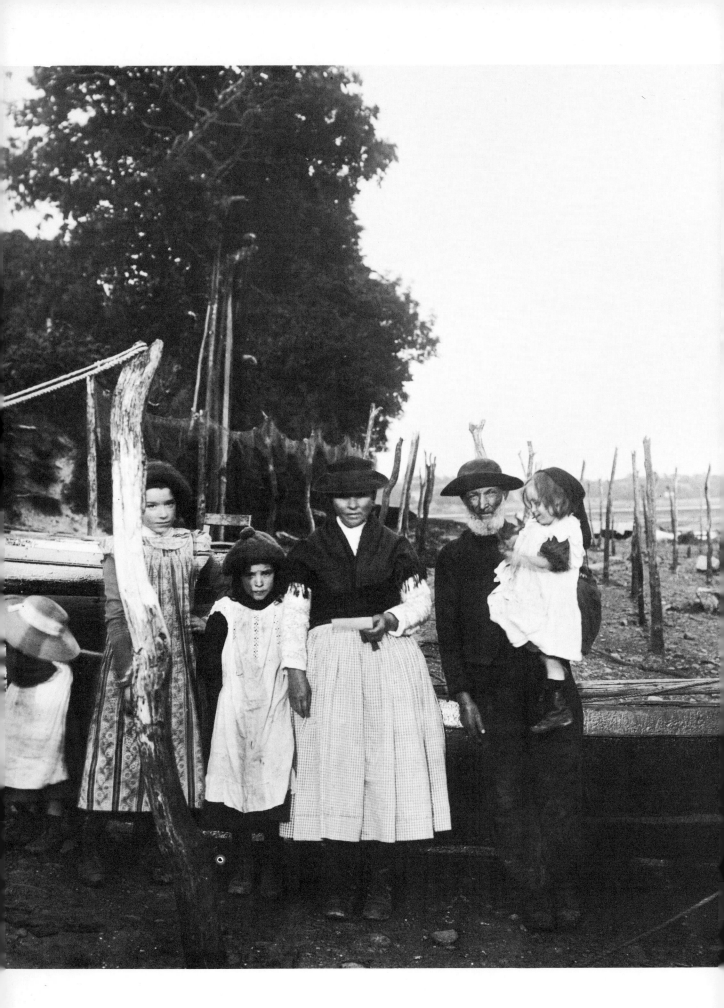

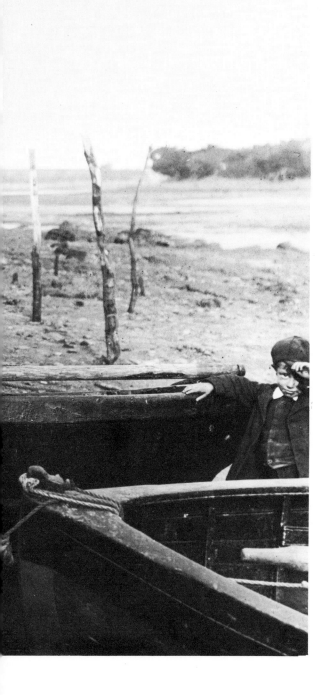

Plate 53

This is also a posed picture, but a more natural one than some of Frith's groupings because it seems to be a deliberate family portrait. It would appear to portray a grandfather and daughter or daughter-in-law, with her four daughters. The little boy on the right I think must be an interloper, probably, from his relatively smart appearance, a visitor's son. Everybody wears lace-up leather boots, even the little child in her grandfather's arms (who may just conceivably not have been there when the photograph was taken, for careful examination of the print suggests that she may have been added after from another negative in the studio).

Llangwm, where this photograph was taken, is far up the tidal river above Milford Haven and the fishery was probably not the only source of income of these relatively prosperous-looking people.

Plate 54 and Plate 55

Frith's habit of photographing posed groups, although it seems to us today rather contrived, was, in fact, very much in the spirit of the times and because of the length of exposure needed it was really the only satisfactory way of recording people; action shots involving much movement were not really practical.

The posing was very well done and the photographs are really no more artificial than the self-conscious forced angles of some modern photographers. As a historical record they are invaluable.

These two plates both show deliberately arranged groups of fishermen photographed at Sheringham in Norfolk, the one simply crowded around the bows of two boats as if interrupted in the course of conversation, the other a posed working scene showing men repairing the local style of lobster pot.

Both photographs contain representatives

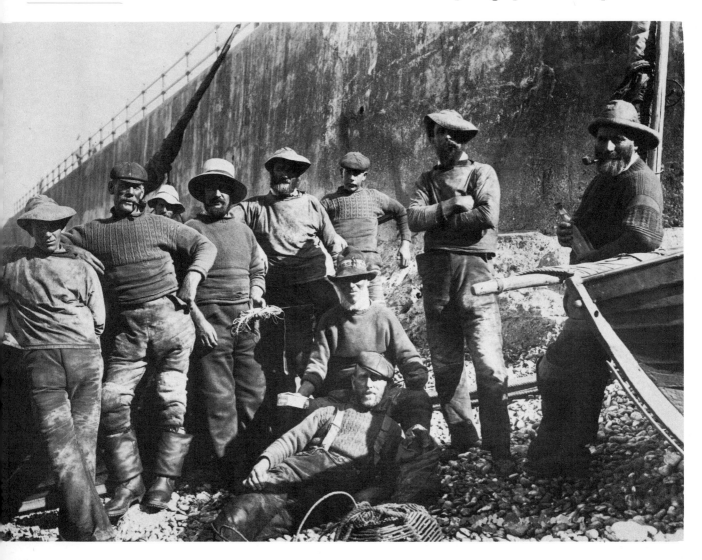

of several generations; the oldest men shown here may well have been born in the 1840s. Notice that the majority are wearing trousers with flaps instead of flies. The sea boots are of leather and required constant greasing to keep them soft and waterproof, and the sou'westers are of the old rigid kind, proofed at home with linseed oil.

Sheringham and nearby Cromer were noted for their crabs and lobsters. In the 1870s the crab season lasted from April 1 to June 20 while the lobster season was from mid-July to the end of September. The fishermen had their own conservation rules as to the size of crabs and lobsters which could be caught. The boats were short, deep double-enders (that is, pointed at both bow and stern) from 15 to 19 feet in length, with oars worked through oar ports cut in the strake and rigged with great dipping lug sails.

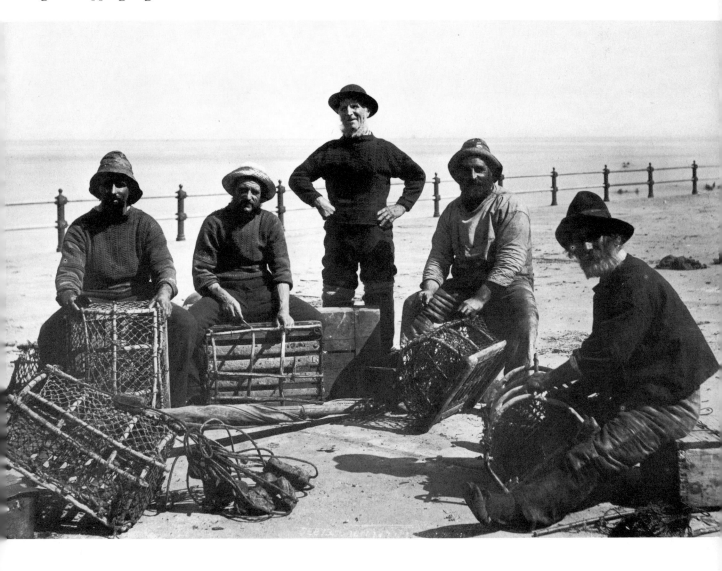

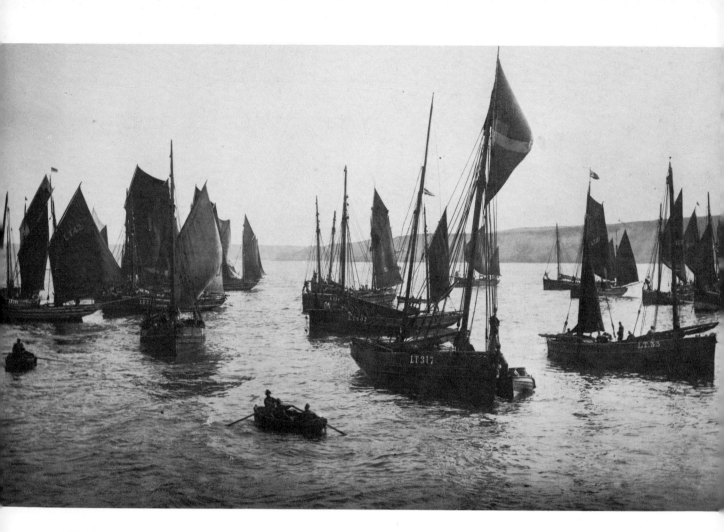

Plate 56

This great fleet was photographed off Scarborough but comprises, as far as can be seen with a glass, entirely Lowestoft boats.

The photograph is of considerable interest. It was evidently taken in the 1880s and it shows a fascinating mixture of vessels. The traditional rig of the east coast drifters had been the dipping lug, rather than the smack rig of the Brixham trawlers. But in the 1870s, the time when the ketches were beginning to come into use at Brixham, a great change to ketch rig also began on the east coast. At this time also the ketch rig in small merchant vessels was coming into use all around the coasts of Britain because it was safer and handier than the smack and more economical than the schooner. The immediate cause of its adoption in the east coast fishing industry was probably the fact that the railways were opening up new markets, and when the herring season was over many of the east coast boats which fished for herring with

drift nets went trawling for other fish because the product could now be sold to inland markets. Their lug rig was not suitable for trawling; although it was more powerful than the gaff rig it was far less handy and was not suitable for the bigger vessels required to operate the beam trawls effectively.

So the new vessels which were built were ketch rigged and many of the old luggers were converted. In this photograph LT 33 is still a lugger; LT 42 and LT 20 have lug mizzens and gaff main or foresails, with a gaff topsail. The short pole masts of the lug rig have been kept, giving the vessels a characteristic stumpy appearance. LT 407 and the vessels in the background are fully ketch rigged, but with the widely spaced short masts which show that they are either converted luggers or that their owners and builders constructed them under the influence of the old rig at this interesting period of transition.

88

Plate 57

By way of contrast with the stumpily rigged Lowestoft vessels, this photograph shows a great fleet of Grimsby trawlers in their home port. The rise of Grimsby as a fishing port was a phenomenon of the second half of the 19th century. In the 1850s there was one small fishing vessel owned there, but by 1891 there were nearly 800 sailing and 35 steam trawlers. Grimsby rose because of the railway. When the fishing industry began to develop at Hull (partly as a result of the discovery in the 1840s of the Silver Pits fishing ground at the south end of the Dogger Bank and the migration of Brixham men to Hull), the dock authorities at first did not welcome the new development, which they regarded as something of a nuisance to docks intended for handling cargoes. As the industry developed, facilities were not improved and so a railway

company, seeing the opportunity, offered inducements to owners to transfer their business to Grimsby, 25 miles nearer the fishing grounds, and by 1877 there were 445 trawlers and 57 smacks working out of the port. The peak of the sailing industry, within a few years of the time this photograph was taken, was in 1887 when there were 815 sailing and 15 steam trawlers operating out of the port.

At Grimsby the facilities were admirable for large-scale fishing, while at Brixham they were quite inadequate for an industry on this scale. Grimsby rapidly developed and by the turn of the century there were only 34 large sailing vessels and nearly 500 steam trawlers. The sailing industry died away, but at Brixham it persisted until after the First World War and for various reasons the steam trawler was not adopted locally.

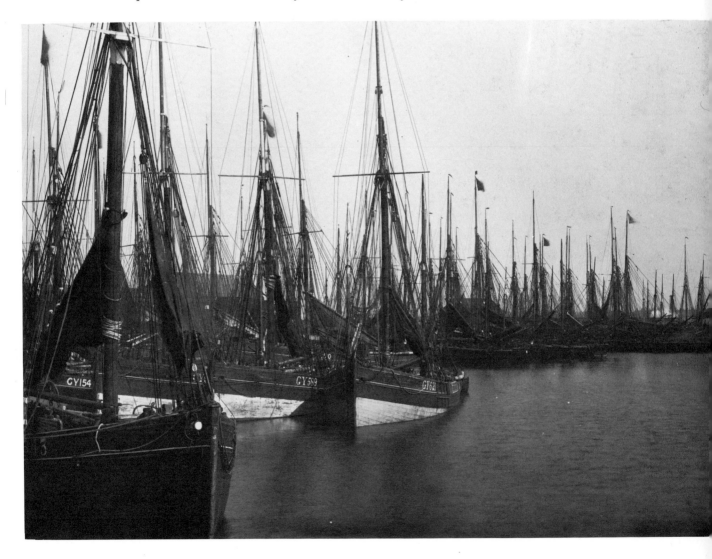

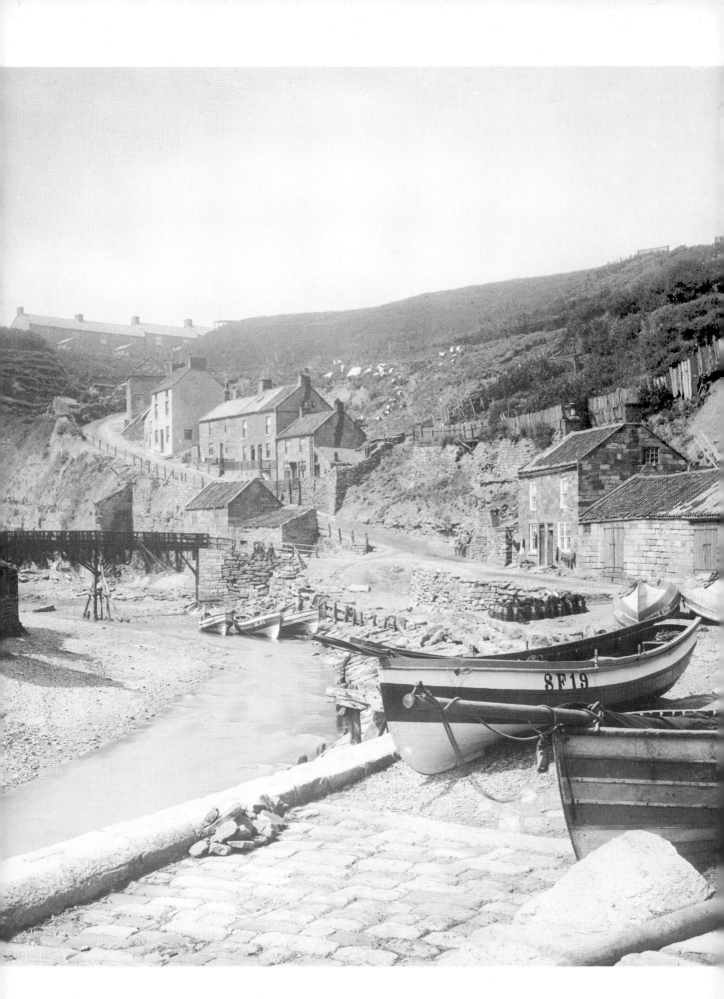

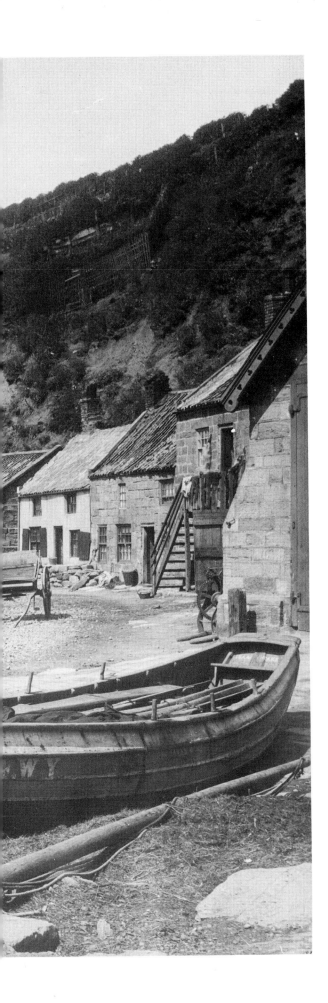

Plate 58 (Left) and Plate 59 (Overleaf)

In the 19th century almost every village down the coast of Yorkshire had its group of fishing boats, almost all of them cobles. The coble from the north-east coast of England with her marked sheer, flattening forward, was, and is, one of the most distinctive local working boats in Britain. With a sharp high bow and very flat sections aft she anticipated some modern power boat practice by many years. She was clinker-built and normally equipped with a narrow dipping lug sail, or rowed with oars worked with an iron ring on a single thole pin.

These are the second oldest photographs in this book and date from the 1870s. The one on this page shows seven cobles, two upright at the head of the slip, two upside down by the cart, and three in the river at Staithes in Yorkshire. There is no harbour here, only a breakwater at the entrance to the creek. In the mid-19th century the cobles used to go out for a whole week at a time in the summer. There were then some 400 men and boys employed in the fishery.

The one overleaf is a magnificent photograph and shows cobles on the beach and hauled out behind the beach at Flamborough Head North Landing. The beautiful shape of the boat, with its double sheer dropping slightly towards the bows, and the marked tumblehome (the turn inwards of the upper strakes), is very apparent. The North Landing was used when the winds were from the north, because it was sheltered by the chalk headland visible in the picture. The cobles were hauled out high above the beach, as they are shown in the photograph, by a steam-engined winch.

Cobles were built at Flamborough by Mr and Mrs Hopwood who built boats between them without any other help, for sale all the way down the coast. A long description of Mr Hopwood's methods and of coble building generally can be found in the first volume of *Inshore Craft of Britain in the Days of Sail and Oar* by Edgar J. March.

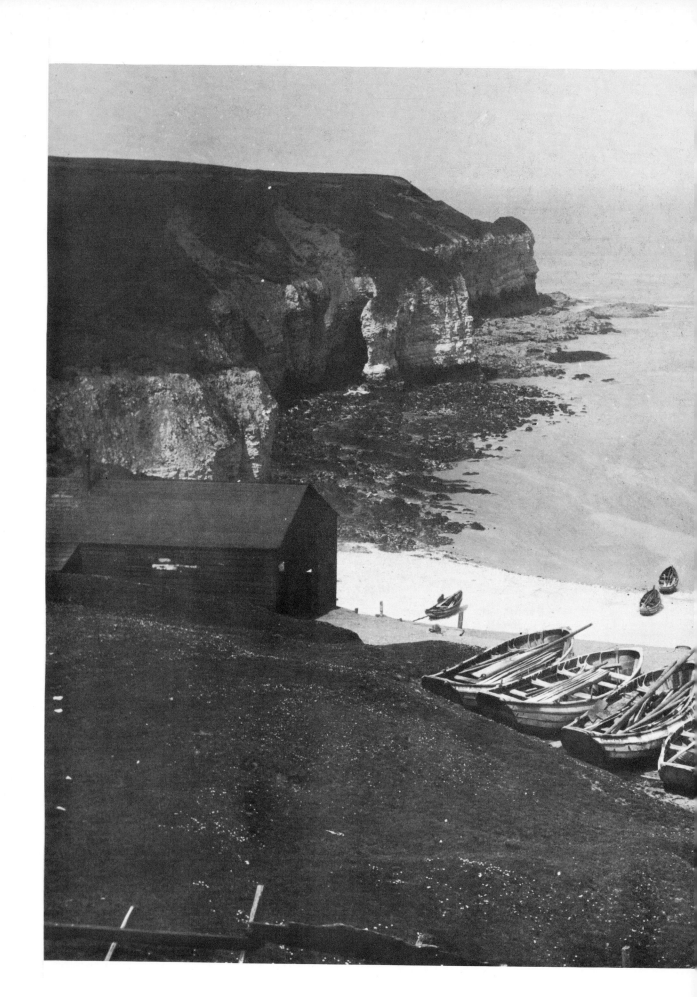

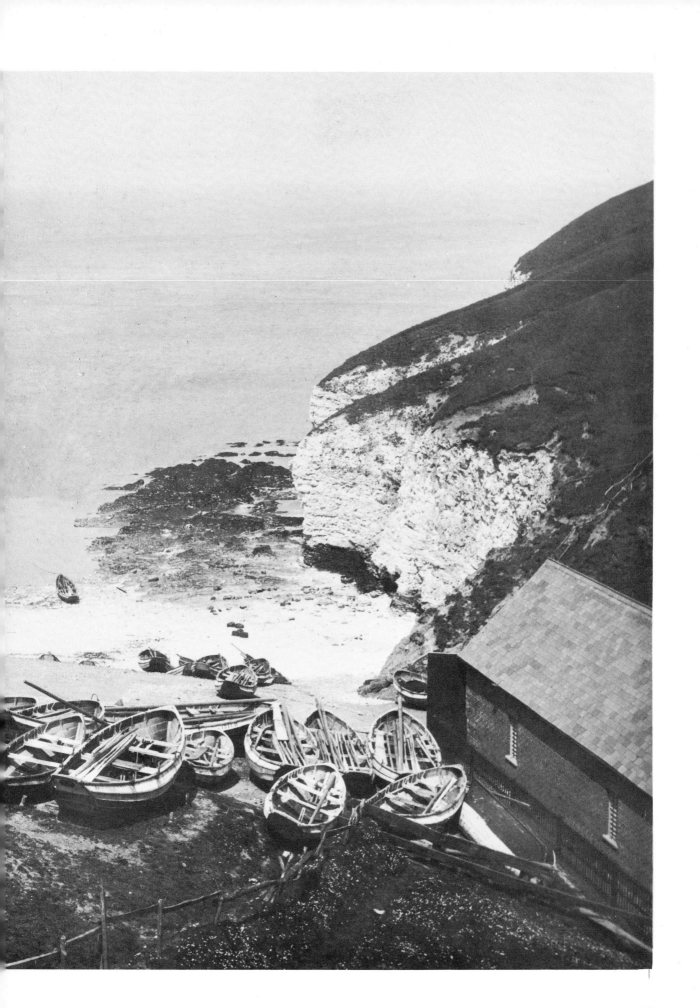

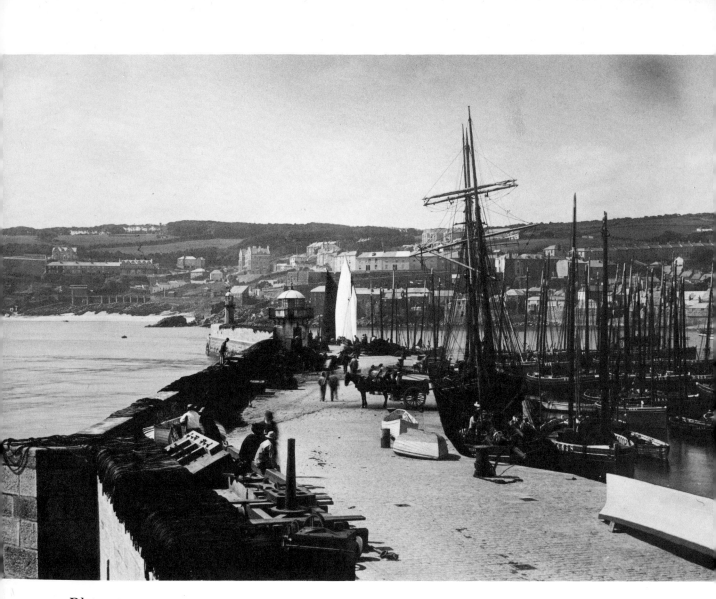

Plate 60

St Ives in Cornwall, now a tourist
resort plagued with 'hippies', was
once a great fishing port with some local
trade with cargoes as well. Here both
activities are well illustrated. Fishing nets
are drying on the quayside and some score
of the local herring drifters are lying in
the harbour. One has what appears to be
new sails set, possibly to stretch, while a
trading smack with a running bowsprit,
the *Willie Warren* (built at St Ives in 1885
and owned by William Warren) and a
two-masted schooner, the *Bessie Belle*
(owned in Morwellham on the Tamar),
discharge cargo into two-wheel carts, the
nearest backed perilously close to the edge
of the quay, its wheels stopped by a piece
of wood. The long narrow gigs on the
quayside are characteristic of North Corn-
wall.

Plate 61

I chose this photograph of St Ives drifters leaving a port in Cornwall partly because it is superbly composed and partly because it shows so well the details of the lug sails and rigging from which boats of this kind derived their name – luggers. The lug sail took several forms and survives in small numbers among pleasure boats today in the simplest – the standing lug.

The boats shown here have dipping lug sails, highly efficient and very simple, needing the minimum of rigging and gear. Properly handled they were good boats for sailing to windward, excellent with the wind on or abaft the beam. Their disadvantage was that they were very awkward to put round through the wind. The big lug sails had to be dipped, that is, lowered to the deck and reset on the other side of the mast, or at any rate the halyards had to be slacked off, the throat dipped round the mast, and the luff of the sail brought back around it and the tack resecured on the other bow. There were various ways of solving the problem but all needed a big crew. This was all right as long as great handiness in stays was not required (as it sometimes was in trawling) and as long as a relatively big crew was needed for the fishing processes carried out by the boat, as it was with these herring drifters, each of which has four men visible on deck. But it would not do for trawling, and so, as already illustrated in previous plates, in places where trawling developed smacks and ketches tended to be used instead of the simpler and cheaper luggers.

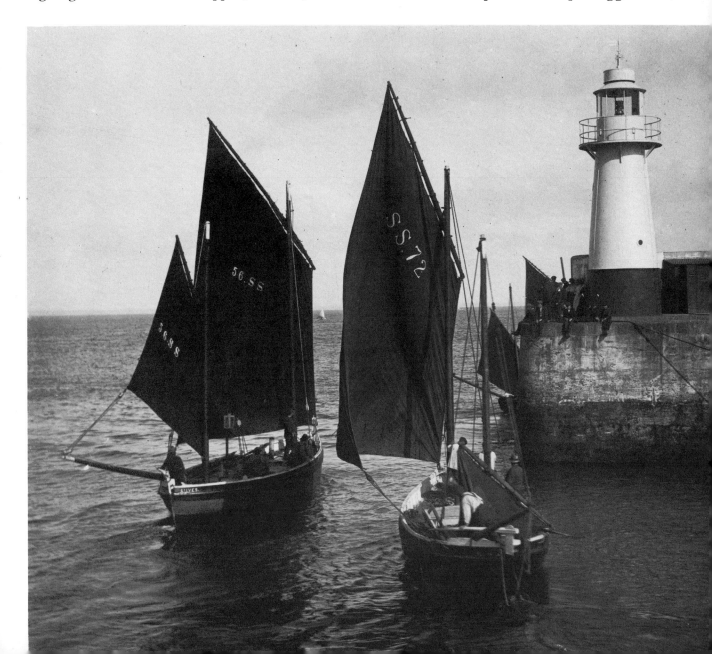

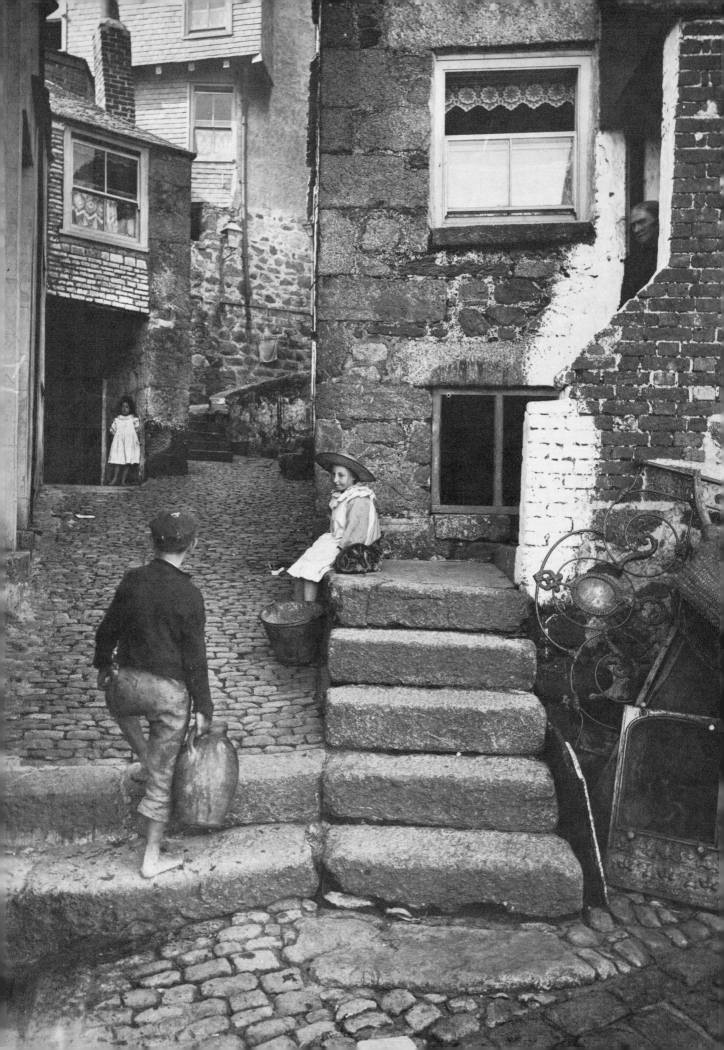

Plate 62 (Left)

St Ives was typical of the 19th-century Cornish fishing community. Its lug-sailed drifters ranged far and wide, and its people lived in damp, granite cottages opening on to cobbled alleyways, some of them not accessible to wheeled transport. They had neither sanitation nor running water nor, of course, any form of heating except open fires. Their womenfolk cooked on coal- or wood-fired stoves, and the children ran bare-footed; shoes, or rather boots, were for Sundays. The lad in this photograph appears to have been drawing water in a jar from a communal pump or tap. It is summer and the little girl and the cat are sunning themselves. Even this place, with its brick-built after-thought porch, can manage the status symbol of a lace curtain. The junk thrown out for the itinerant scrap dealer would now fetch high prices.

Plate 63 (Below)

The hard life of the fishermen of sails and oars contained a great deal of waiting – simply waiting – for good weather, for the tide, for the fish to run, for prices that made it worthwhile to fish. This photograph taken in Newlyn illustrates this waiting very well. Newlyn rose with Cornwall's 18th-century industrial revolution, and in the 19th century was the home of a large fleet of lug-rigged drifters, famous as the pointed-sterned Penzance, or Mount's Bay, luggers. Newlyn luggers caught mackerel, pilchards and herring, going as far afield as Ireland and Scotland to do so.

This photograph shows the old harbour, a tiny space enclosed by a quay wall first built in the early 1400s, now completely enveloped by a much larger 19th-century group of quays, one of which is visible in the background. The boats are the local double-ended luggers. Instead of dragging a bag or net held open by a wooden beam over the floor of the sea, like the Brixham, Grimsby and Lowestoft boats, these vessels, like those from St Ives, lay at the head of long curtains of net hanging down from floats in which the fish were caught individually by entangling themselves in the meshes. Each fish had to be removed separately from the net.

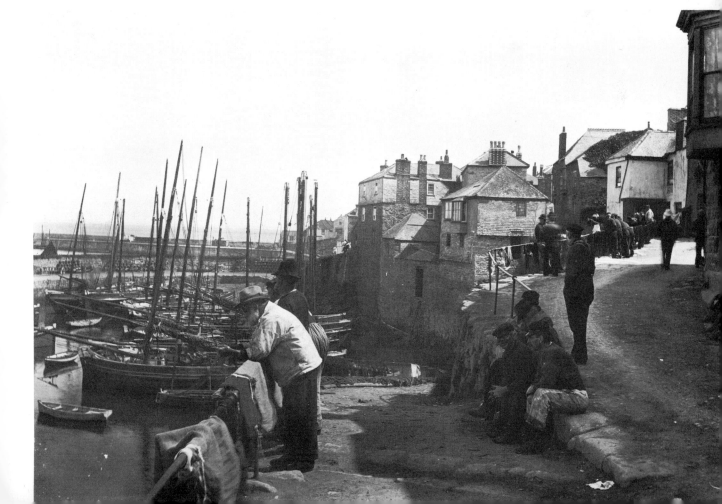

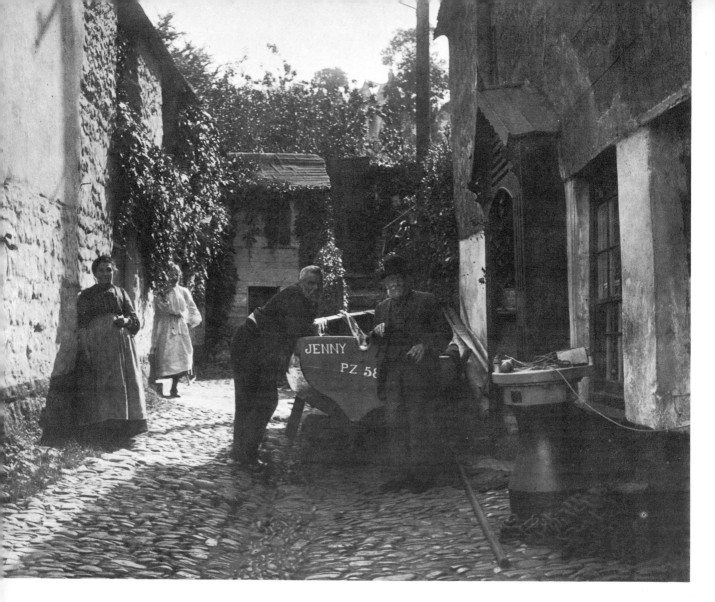

Plate 64

This picture shows a back street of Newlyn with some of its inhabitants, and *Jenny* which was a small boat of a type used for crabbing around the coasts west of Mount's Bay, and a variety of nautical gear. This deliberately posed photograph is more natural than some – the old lady in the white overall was later persuaded to come out and a photograph taken shortly after shows her in semi-close-up. It must have been taken within a few years of the great local clash between the trawlers and drifters. Drift net fishing, conducted in the local luggers, did not disturb the bottom of the sea. Trawling, on the other hand, even with the primitive beam trawls dragged by sailing ships, could damage the fishing grounds. Worse than this, with the coming of the railways into West Cornwall, although the prosperity of the local drifters was at first improved now that they had

access to much wider markets, trawlers, not only from Plymouth and Brixham but from the east coast ports, were drawn to use those same facilities, trawling over the best local grounds and interfering with the nets of the drifters, whom they regarded as being in the way. Moreover, the east coast trawlers, miles from their bases, worked on Sundays, which the west-countrymen did not. In 1896 the exasperated Newlyn drifter men rioted against the trawlers coming into Newlyn and Penzance to land fish and the army had to be called in to restore order.

The luggers of the westcountry lingered on until the First World War and even after, but the fishery was doomed. Today, however, Newlyn is the largest and most prosperous fishing port in the south-west of Britain.

Plate 65

Polperro is a spoiled tourist resort to-day but at the time this photograph was taken it was a village dependent for its living on the local inshore fishery. Crouched around a small harbour, like so many fishing settlements all over the world in a way rejected by the land and the people with land, the group of cottages of the impoverished landless fishermen, who led even harder and poorer lives than those of the farmworkers in the hills behind the coast, took a form exotic to the general landscape. Whatever may be the image presented today, the life in Polperro when this photograph was taken was exceedingly rugged, despite the picturesque cottages and beautiful boats.

The photograph, in the finest Frith tradition, shows Polperro when it was a real place. The group of men at the end of the pier look down on boats which despite their size are not even decked. The only protection from the weather is the very small cuddy forward, and some of them do not appear to have even that.

Compare this view of a grey and white poor little village with the fiction of a fishing village Polperro presents today, the cottages still identifiable but plastered and colour washed, the inner harbour walls and lime kilns pulled down, and the outer walls extended and improved after the great gale of 1891 when most of the local boats were destroyed. This is one of the earliest photographs in this book, and was taken nearly 100 years ago.

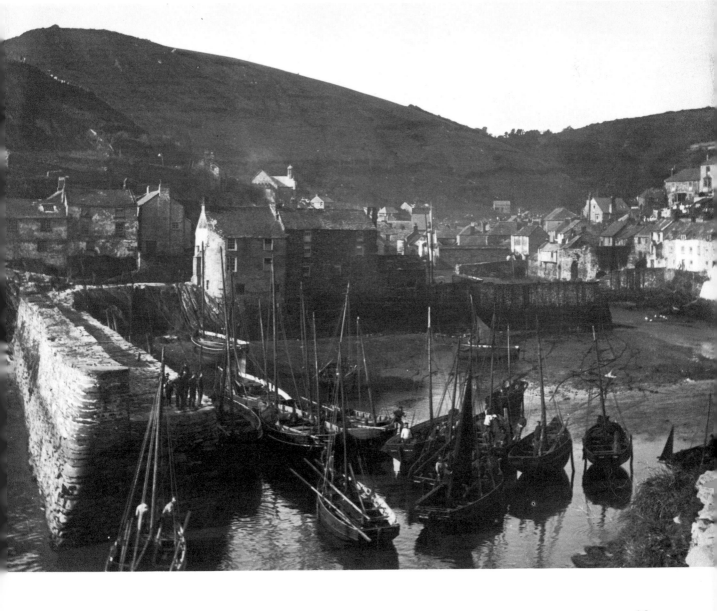

Plate 66

gain a splendid composition, this photograph, also taken in Polperro, and from its serial number on the same day as Plate 65, shows the scales on which the fish were weighed when they were sold to the dealers – the first of the middlemen who came between the fishermen and the consumer and took much of the profit. The men and women shown here lived mainly on potatoes grown in their own plots and on pilchards. The cloth in their clothes was made in the country and turned into suits by tailors earning a shilling a day and their food. The nets in which the fish were caught were bought from Bridport and repaired in the village by the women and children. It was not until the latter part of the 19th century that the boats began to have even the small cuddy shown in the last photograph, and these men grew up in entirely open boats, sleeping on the bottom covered only by a canvas sheet or a sail. Notice how the street and the harbour mingle with no clear line of demarkation between them – a characteristic of peasant fishing communities the world over. Notice also the superb way in which the photograph has recorded the surface texture of the slate-hung building in the middle foreground.

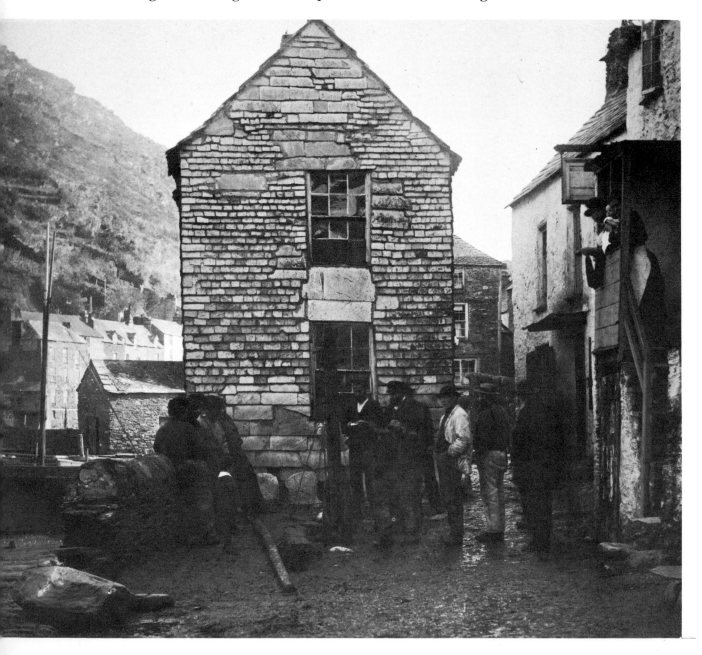

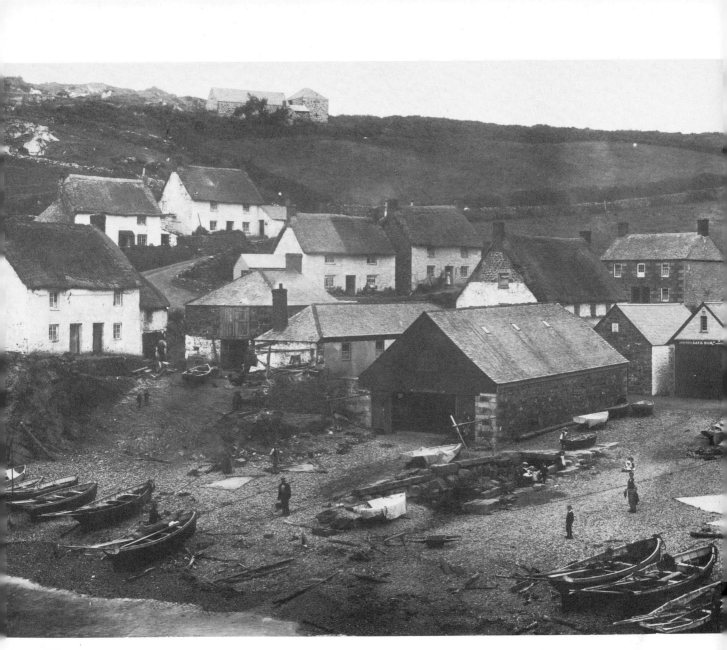

Plate 67

I have chosen this photograph of Cadgwith at the end of the last century to illustrate a Cornish fishing beach. This cove, on the east side of the Lizard, was the home of a beach fishery, as opposed to the fisheries based on small harbours so far shown, a small fishing community which the photograph illustrates extremely well. The lug-rigged boats are hauled out of the water and on to the beach, their masts unstepped and stowed in the boats with the yards and gear. Sails are drying over the boats and spread out on the pebbles, and the beach is littered with rollers used to haul out boats which are away fishing. The general messy appearance was typical of a beach fishing community. Beaches in Japan and on the east coast of Canada, where there are still today communities dependent on a local fishery in the way that this one was, are often even more untidy.

Not clearly visible in the photograph are the decaying fish heads, offal and unmarketable whole fish which were usually to be found on beaches like this by both sight and smell. A two-man tub, or trog, with handles, for carrying fish up the beach, is lying right in the middle of the photograph. Local children are playing. The cottages are either grey stone or slate or white – no colour wash. The lifeboat station was opened in 1867 and closed 93 years and 80 rescue trips later – nearly 400 people owed their lives to its successive boats.

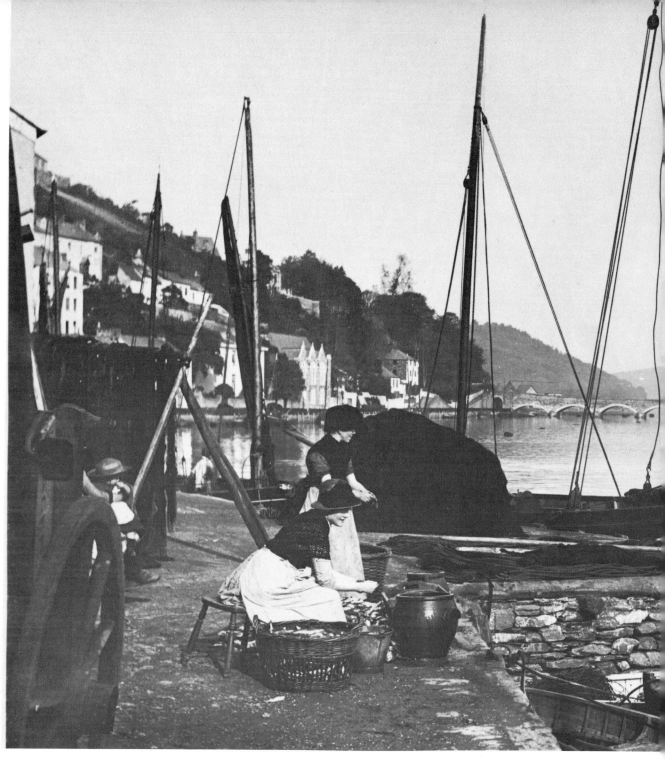

Plate 68

Looe is now almost entirely a holiday resort, one which attracts many local people from adjacent inland parts of Cornwall and West Devon as well as from much further afield. In the 19th century it was a moderately busy fishing port and also a place of export for granite from the moorland quarries above the town. The granite was used for the docks at Plymouth and Portsmouth and for Westminster Bridge and Dover Breakwater.

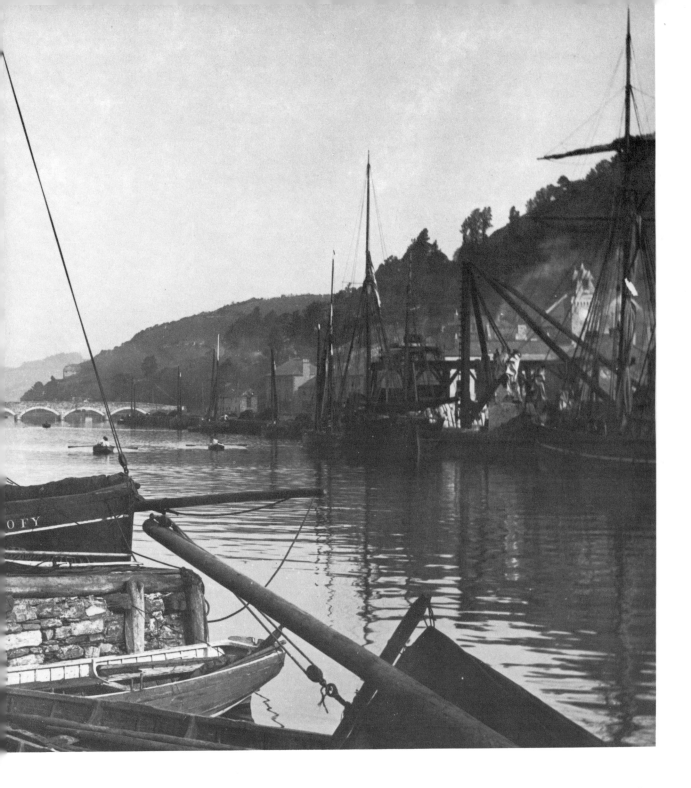

This photograph, again very well composed, shows a Fowey-registered lugger probably locally owned with her great drift net in a heap on the quay beside her, and a ketch and a schooner loading cargo. Two women are gutting fish on the quay side, while a child plays behind them. Of these women a writer 25 or 30 years before this photograph was taken early in the 1880s wrote, 'the women take a very fair share of the hard work out of the men's hands. You constantly see them carrying coals from the vessels to the quay in curious hand-barrows, they laugh, scream, and run in each other's way incessantly. As to the men, one absorbing interest seems to govern them all. The whole day long they are mending boats, cleaning boats, rowing boats, or, standing with their hands in their pockets, looking at boats.'

In some ways a few of us today perhaps might envy the men.

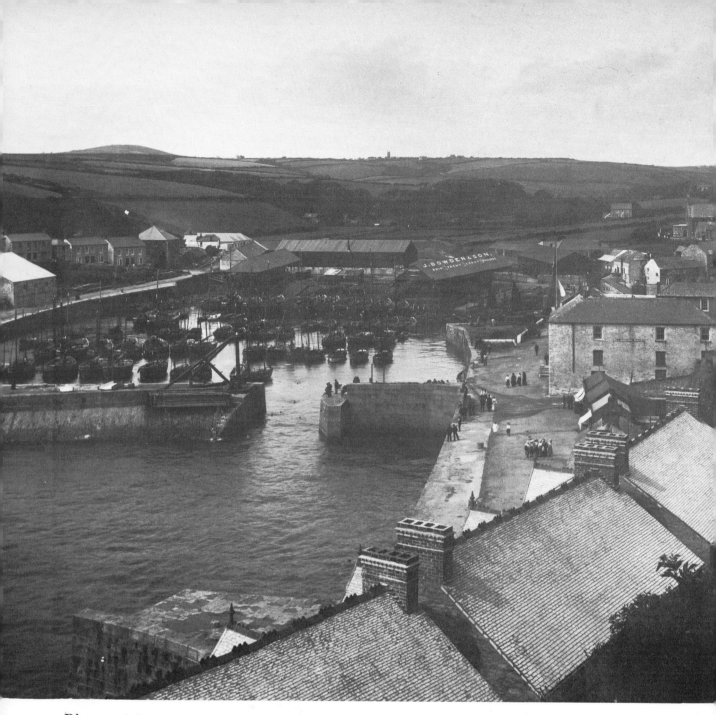

Plate 69 (*Above*)

Porthleven is a strange creation of the early 19th century when an artificial harbour was made by over-optimistic promoters in a little cove facing south-west – the direction of the prevailing wind. Hundreds and thousands of tons of mud and gravel had to be excavated and the alleged primary purpose of making a harbour of refuge was, in fact, never fulfilled. But in the 19th century Porthleven had its own small fishing fleet as well as some small coastal trade. It also had a small shipbuilding industry noted, among other classes of vessel, for building pilot cutters for the Bristol Channel, at least one of which is still afloat as a yacht. This photograph shows the fleet and the covered building slips. It also shows the crane with its baulks of timber which were dropped between the two piers at the entrance to the harbour to cut it off from the open sea, so as to break the ground sea and prevent it from destroying the boats in the inner harbour when the south-westerlies blew strong. But it was always a very difficult port with small commercial use, despite its proximity to a rich mining area.

Plate 70 (Below)

This is a fish market going forward by the side of a westcountry harbour. Notice the woman in the white apron and dark shawl with the fish basket slung on her back by means of a band around the top of her head. She appears to be checking some kind of statement. Besides those directly concerned with the business there are a number of spectators, presumably holiday makers from their dress, and from the serial number this represents a working and holiday crowd a few years after Queen Victoria's death.

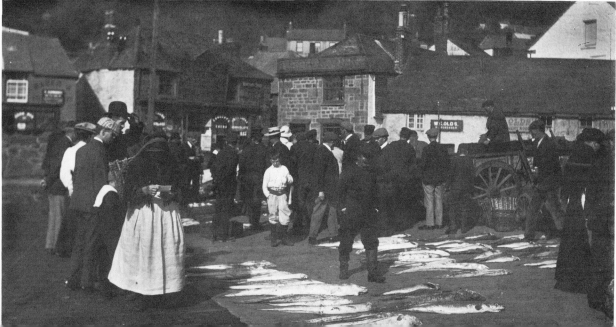

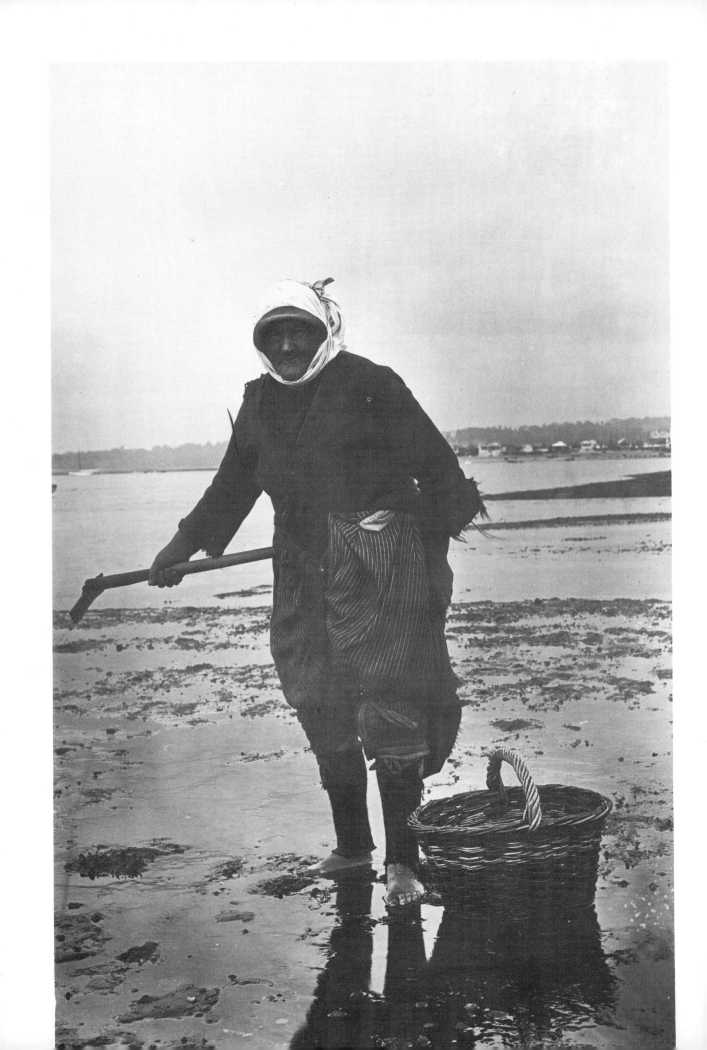

Plate 71 (Left)

It appears that this photograph was taken on the flats just north of Exmouth in South Devon on the shores of the Exe estuary at low tide. From the appearance of the woman it was taken in a cold spell. She is dredging for cockles, found in the hard mud, and by doing this she scrapes part of a living, selling them at a very low price to local fish dealers. Notice that she has no boots and that her face is seamed and weathered with hard work and exposure. She is probably a good deal younger than she appears to us now.

Plate 72 (Below)

These boats are hauled out on the beach at Beer in South Devon. Each has an Exmouth registration number and they are rigged as luggers. Four of the small standing lug mizzens are set to dry and a number of the boats have nets drying from spars hauled up the mainmasts by the main halyards. The small boat in the foreground has been adapted to take an inboard motor and the nearest of the luggers, E 246, also has a motor and propeller, as do possibly one or two of the others. However, they all retain their sailing rig and the long downward pointing iron bumpkin jutting out from the stem to which the tack of the big dipping lug fore-

sail was secured. Each bumpkin has two rings on it for the tacks of different sizes of sail, one for summer use and one for winter.

The photograph was probably taken around the time of the First World War. Beer was one of the first areas in the country in which motors were adopted by beach fishermen, partly as a result of the work of Stephen Reynolds, a young writer who settled a little further down the coast at Sidmouth, was assimilated into the local community and wrote brilliantly of the lives of the beach fishermen and their families. His books, now difficult to obtain, take the reader right into the very guts and soul of the fishermen's lives, telling of much that was gentle and kindly in their background but also of what poverty, disease and hunger meant, the hardships both of the families at home and of the fishermen in the boats, scraping for a living with their luggers and nets. These boats had no protection for their crews against the weather. Each time they came in they had to be hauled up the beach by men labouring at winches. A fisherman with one of these luggers had little or no hope of making capital and becoming reasonably prosperous. There was almost no escape from this kind of poverty.

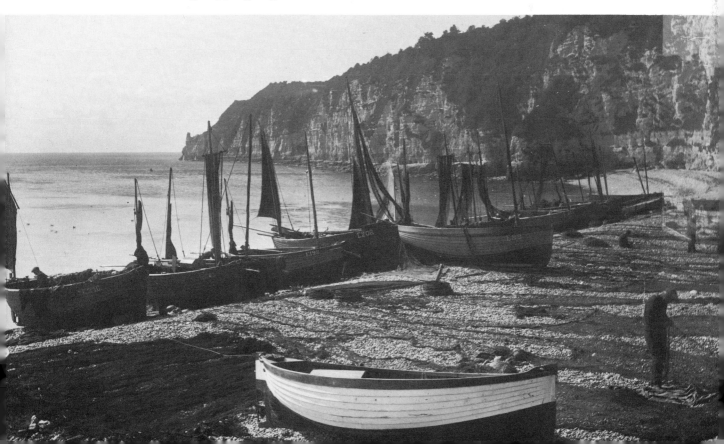

Plate 73

It used to be said by elderly men in Plymouth that in their youth there were so many trawlers and drifters at times in Sutton Harbour, Plymouth, that it was possible to walk across the harbour by stepping from boat to boat. The fact that there was some foundation of truth in this statement is shown by this photograph taken in Sutton Harbour in the late 1880s or early '90s. These were not efficient fishing units, but each made something of

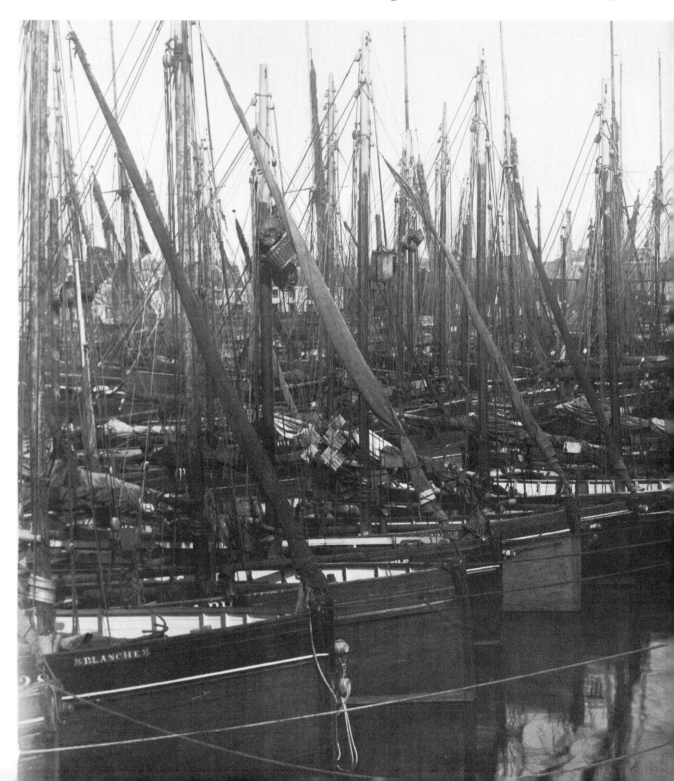

a living for a number of families. They are mixed trawlers and hookers, that is, smacks and small ketches employed in fishing with long lines, each with 1,000 to 3,000 hooks attached to it.

Plymouth boats on the whole did not fish all round the British coast like those of Brixham but confined their activities to the coasts of South Devon and Cornwall. But even so the hookers, like those in the immediate foreground of the photograph, would go 50 or 60 miles off the land in pursuit of hake, halibut, conger, sole, brill, skate and whiting. Many of the hookers were built at Porthleven in the yards shown in Plate 69. The beam trawlers operated inshore, some of them joining with Brixham men in Mount's Bay and playing their part in the circumstances which led to the Newlyn riots of the early 1890s described in the caption to Plate 64.

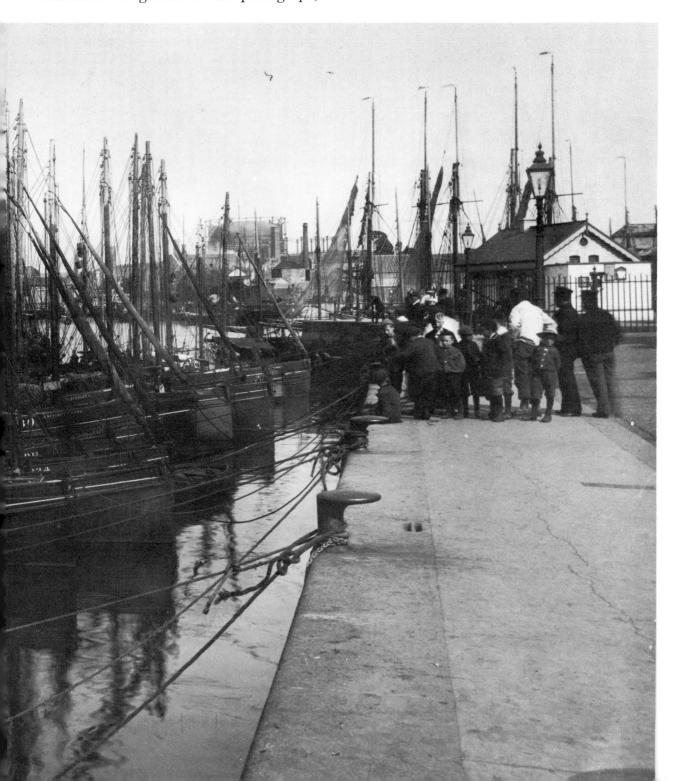

Plate 74

This photograph taken in the 1880s
shows Mevagissey, a Cornish fishing
harbour at the height of its prosperity.
Mevagissey was never the base of big
trawlers and hookers like Brixham and
Plymouth, but like Looe and Polperro was
the home of a considerable fleet of open
and half-decked boats, lug-rigged, and
employed in drift net and line fishing.
Considerable numbers of them can be seen

in this photograph lying on the mud of the dried-out harbour. There are also three schooners, including one in the distance drying her sails and one in the immediate foreground, the *Marshal Keith* of Peterhead, a splendid example of a big sharp-hulled two-masted schooner of the old type with an enormous spread of canvas especially on the mainmast. The main boom must have been a huge spar. She was built at Peterhead in 1864, and this photograph shows her decks in considerable detail, the galley immediately abaft the foremast, the small hatchways through which the cargo was loaded into the hold, the whale-back wheel shelter to protect the steersman from seas coming up astern and the open wheel. The two big barrels immediately abaft the after hatch probably contained the principal supply of fresh water on board.

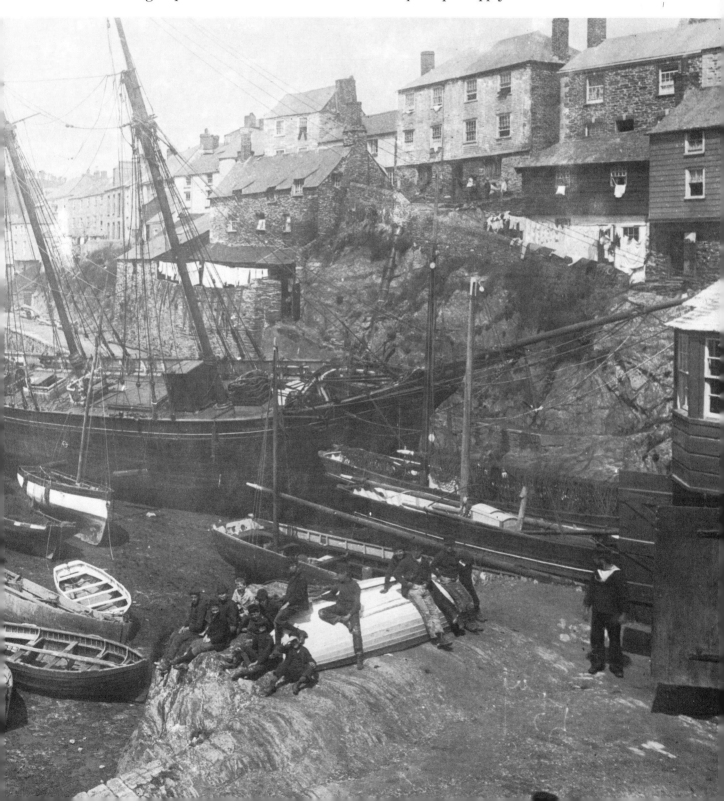

Plate 75

By way of contrast with the other photographs in the first section of this book, this picture shows the steep approach to the beach at Bucks Mills in North Devon. It is full of interesting things. Although it was taken early in this century, pack donkeys were still used to bring material up and down from the beach, each donkey with his boy in charge. It is still not possible for a car to reach the point shown in the photograph. Behind the boys and their donkeys is a lime kiln built into the cliff side. The stone and hard coal for this kiln were brought on to this open rocky beach from South Wales in small brigantines and smacks which lay ashore through one ebb tide, beaching on the flood and hoping to leave again on the next flood. They could only do this, of course, in good settled weather and their masters had to have very detailed local knowledge in order to be able to conduct the trade successfully without loss for many years.

The fishing boats of Bucks Mills were small; three of them can be seen on the beach in the photograph, covered up with old sacks and sheets of canvas. They, too, were hauled up the beach on the flood tide and the winches with which this was done can clearly be seen on the stone terrace at the foot of the cliff. The fishery was a small local one, principally for herring, complementary to the larger fishery from Clovelly, a few miles further west. It could only, of course, be operated in good weather. The little boats, beautifully built in Appledore, were only 10 or 11 feet long, and sailed under a single dipping lug sail or were rowed.

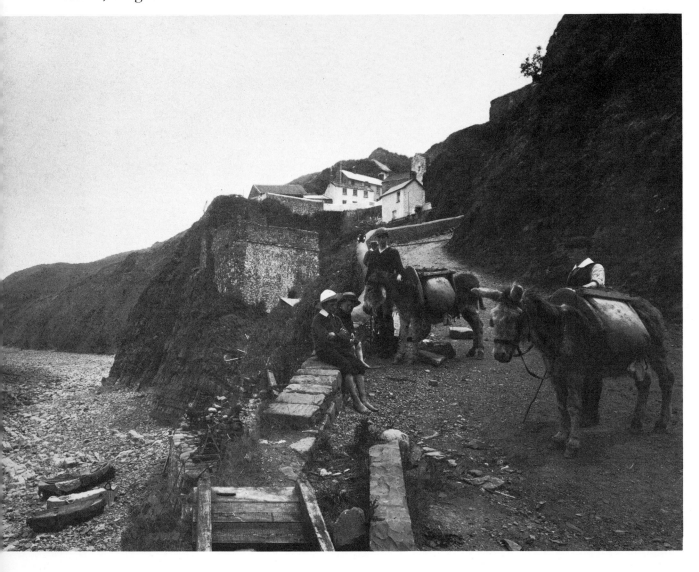

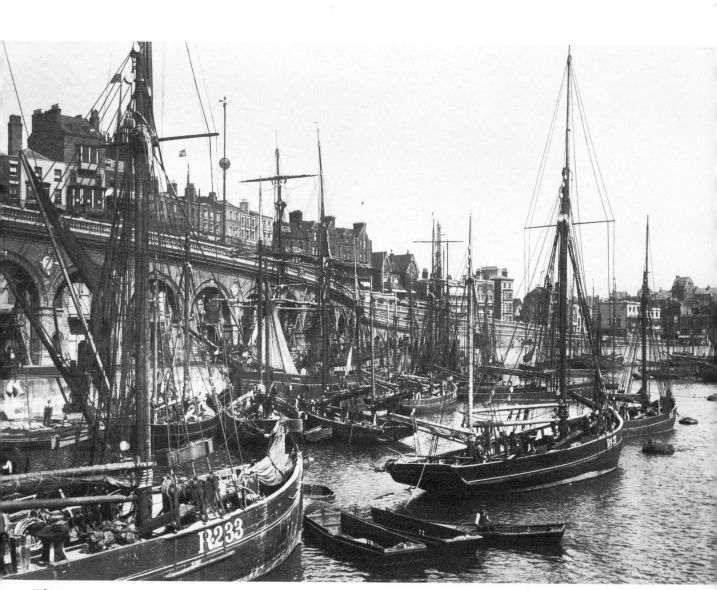

Plate 76

This is a view of Ramsgate, another port which rose as a fishing centre as a result of the migrations of Brixham men. It was not until the Brixham boats began working out of Ramsgate in the early 19th century that the local drift net industry was replaced by trawling. From then on the fleet steadily expanded until in the 1880s and '90s Ramsgate had a truly magnificent fleet.

This photograph, which was taken in the 1890s, shows no less than ten big local fishing boats besides three cargo vessels, a London River sailing barge against the quay, a brigantine, the *Gloriana*, and a barquentine.

The cross fertilisation which existed among the big sailing trawlers, stemming, as so many of them did, ultimately from a Brixham root, is shown in the place of build of these vessels. The boats illustrated here were built at Rye, Porthleven, Galmpton on the Dart in Devon, Lowestoft and Whitstable as well as at Ramsgate itself. Of the two in the immediate foreground, R 233, named *Valiant*, was built at Ramsgate in 1872 and R 427, *The British Queen*, at Rye in 1879.

Section 8
BEACHES & CREEKS AS SHIPPING PLACES

It was of the essence of much of the trade around the coasts of Britain in the 19th century that it was local, serving small communities near navigable salt water. Vessels loaded and discharged at riverside quays in creeks and by the side of farmyards far inland. They also loaded and discharged cargoes on open beaches, in coves and cracks in the rocks, often without any harbour facilities at all. This was the way the transport arrangements of a great many coastal river and creekside communities were managed for centuries until the First World War.

The next few photographs illustrate the trade on to beaches and to quays in tidal rivers and creeks which was still conducted by small sailing vessels in the second half

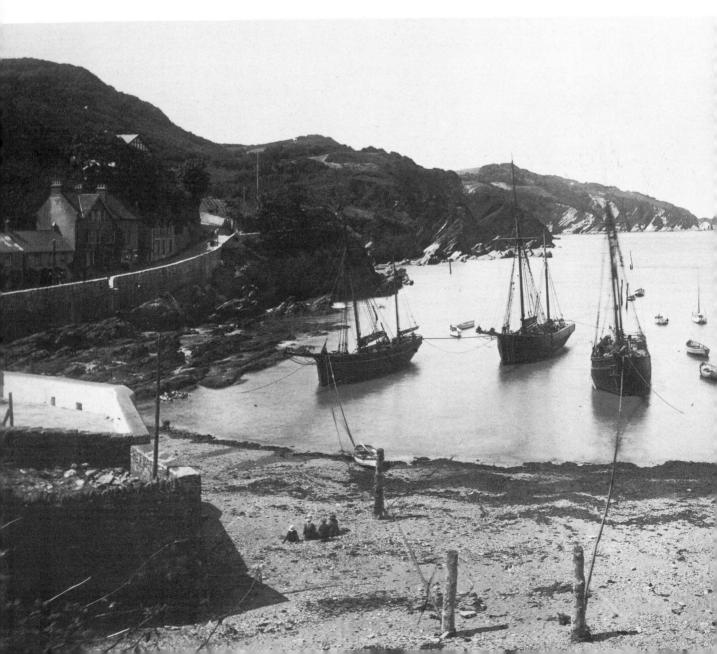

of the last century.

There are many coves and beaches where today the remains of old lime kilns, needing coal and limestone for their operation which can only have come in by sea, still show that a trade was once carried on. Some of these beaches are apparently completely exposed to the open sea and they look very dangerous, but during late Victorian times, as for centuries before, in periods of business prosperity dozens of small smacks, brigantines, schooners and later ketches used them as harbours.

It all depended on local knowledge. But much of the trade was in the summer months, and, like the fishermen who operated from beaches, the men who handled these smacks and ketches could foretell weather conditions in an almost uncanny way and they had knowledge of the tides and conditions of every beach which they

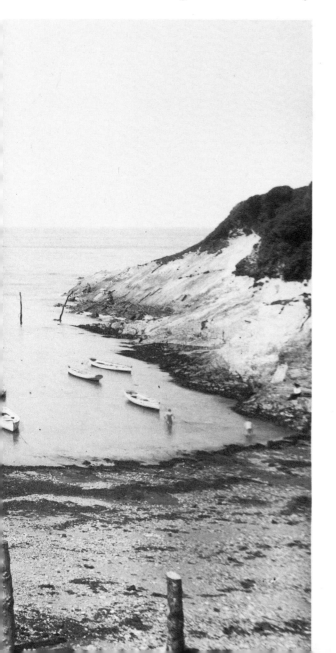

were likely to use. They could judge whether it was going to be fine for a day or two by all sorts of natural things, such as the look of the sky, the actions of the sea birds, animals and even flies, and the long periods for which these beaches were used without the loss of a vessel show that they were usually right.

Plate 77

This is one of the beaches to which small smacks and ketches traded. It is called Combe Martin and is situated on the North Devon coast about three miles above Ilfracombe. It is open to northerly gales but as any northerly wind cuts the ground sea down, no vessel was ever, in fact, known to be damaged seriously here. Notice how the vessels are moored to big posts sunk in the ground by very large hawsers both forward and aft.

In the late 19th century there were always several small ketches owned in Combe Martin continually running both summer and winter. In the original photograph it is possible to read the name of the vessel on the far left. She is the *Jane*, and her history is fairly typical of one of these little beach trading sailing vessels. She was built at Swansea in 1851, and rigged as a smack until the 1880s when she was converted into a ketch. Twice in her life she was lengthened amidships and at the time this photograph was taken she was 54 feet long. She was owned by John and George Irwin of Combe Martin, Devon. These two sailed her themselves and she used to land coal cargoes at a little cove below the Bull Point lighthouse, a place much more exposed than Combe Martin.

When I was a boy growing up on the Somerset coast to the eastward of Combe Martin between the two world wars, there was a very pretty little ketch with a very long topmast still owned in Combe Martin by a later generation of the Irwin family and still trading on to this beach. She was the *Ann*, one of three very similar ketches built by William Date of Kingsbridge, South Devon, in the 1880s and she may well be the centre vessel of the three shown here. Another of this trio, the *Effort*, is shown in Plate 34.

Plate 78

This really is a very fine photograph. It shows the cove called Porth, near Newquay in North Cornwall, which served as a shipping place for the surrounding district for many centuries. There seems to be a lot of sea running into it, but the shallow water in the entrance to the cove causes the sea to break into white foam. It is not a high sea and the foam will disappear when the tide flows up. The ketch lying on the beach is in almost completely smooth water. The wind is coming in from the north which on the north coast of Devon and Cornwall tends to cut down the heavy ground sea that comes with a west or south-westerly wind. It was the ground sea that was really dangerous for the little vessels.

The ketch has two big ropes out aft. When the tide flows in on the flood, she will be allowed to run ahead and up the beach and into even smoother water, and then she will be able to discharge her cargo into carts which will come down the beach. Notice the cows at the back of the beach up on the right-hand side. Notice, too, how few buildings there are, and how lonely the place is. The photograph was taken at the beginning of the 1880s, if not before, but vessels continued to trade into Porth until the First World War.

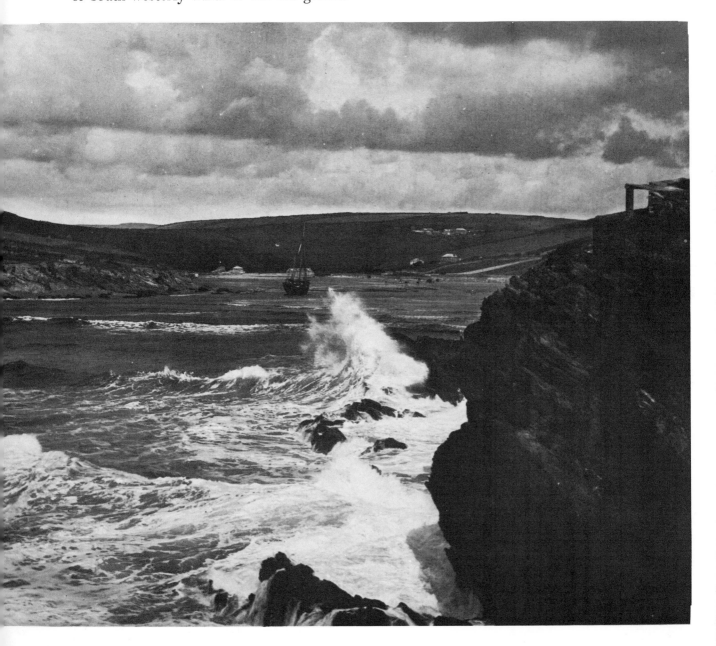

Plate 79

This is one of my favourite photographs in the whole collection and it is one of the very few to have been reproduced before – it is featured and described at length and in detail in *Westcountry Coasting Ketches* by Captain W. J. Slade. It is possible to date it pretty closely. It was taken not later than the summer of 1867 at Porth Gaverne, one of the small Cornish beaches to which little vessels traded. Notice the enormous hawsers with which the vessels are secured. The vessels have special openings in their stern for these big hawsers, which means that they traded regularly to these open beaches. The smack, the vessel nearest the camera, is discharging coal into a cart which has come down the beach. This operation is carried out by means of a hand winch worked by the two men of her crew. She steers with a tiller, as practically all these small cargo vessels did in Victorian times. This smack is almost certainly the *Electric*, built at Porth Gaverne in 1862, while the ketch behind her, which is loading slate that has come down from the Delabole quarries in four-wheeled carts, is the *Jane*, built at Bideford in 1802. She was lost in January 1868, probably not very long after this photograph was taken.

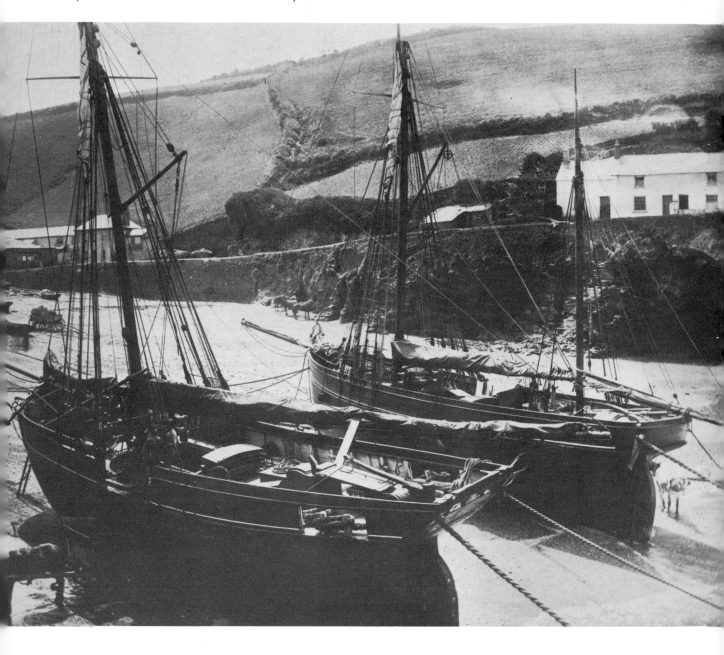

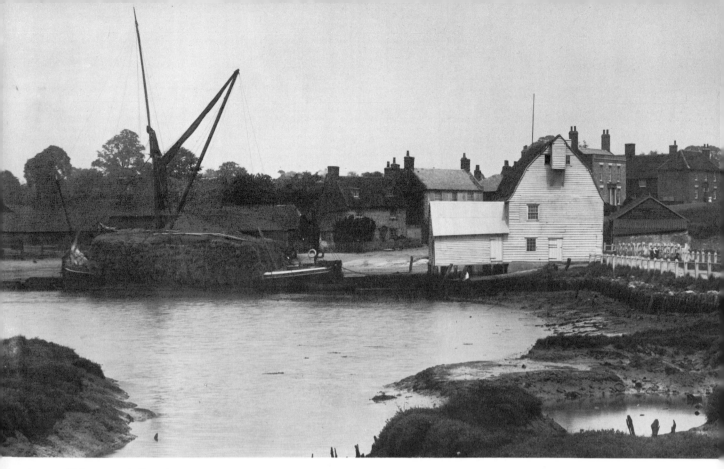

Plate 80 (Above)

One of the most important trades of the London River sailing barge was to bring to the metropolitan area the vast quantities of hay consumed each day by the thousands of horses which worked in the streets before the days of motor transport. This hay came from the waterside farms and villages of Kent, Essex and Suffolk, and the barges that carried it were loaded until they were virtually floating hay stacks. They took back to these same farms the valuable manure from the London streets and stables, and their trade was described as 'hay up, manure down'.

This photograph shows one of these stacked barges lying in an east coast creek, fully laden and ready to leave on the flood tide. Her cargo came down to her in farm carts and would have been discharged into drays which rattled over the London cobble stones. Notice that she would be able to set only half her great sprit mainsail and that there is a ladder leading up on to the top of the stack from the after deck. The steersman would have been very dependent on the other member of the crew to con him through the shipping in London River. Needless to say, the handling of these laden stack barges was a very skilled and specialised business.

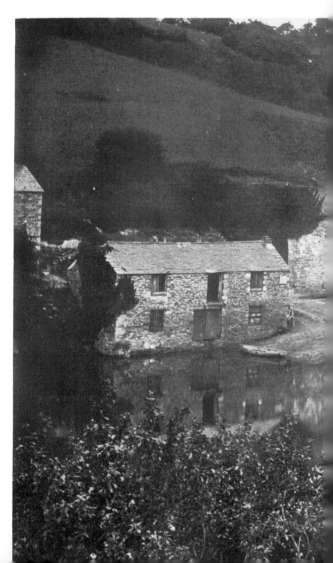

Plate 81 (Below)

This is Pont, a little settlement at the head of Pont Pill, the creek off the Fowey River behind Polruan in South Cornwall. The creek is almost empty at low tide; the photograph was taken at a spring tide flood and I have chosen it partly because of its photographic quality and partly because it is such a very good illustration of that penetration of the sea into the land that made water transport so practical and important until the coming of the motor lorry.

The little ketch, the *Rival*, built at Fowey in 1889 and nearly new when this photograph was taken in the 1890s, is deep laden, waiting to begin discharging her cargo. Her discharging gear, that is, the cargo gaff acting as a crane, has been rigged and the covers put on the sails. Her cargo is evidently coal and a large part of a previous shipment is heaped up on the quayside. She would have brought this coal round from Plymouth in all probability and it would have been taken to there in a steam collier or a larger sailing ship, probably from somewhere in the Mersey area. Now it will be picked up in carts and delivered to the farms for miles around, making only the last short stage by means other than the sea. Until the First World War, this was the way in which the coal was brought to the farms of Devon, Cornwall, Wales and Scotland which were within any reasonable distance of navigable water.

There are other interesting things about this picture. Notice the schooner's galley, lying by the lime kiln on the right-hand side of the photograph. Taken from a worn out vessel it is probably going to be used as an outhouse, like the galley by the gate in the immediate foreground. The two boats are rigged with spritsails and mizzens, and appear to have holiday makers in them. The *Rival* evidently lands cargoes on the beaches like the vessels in Plates 77, 78 and 79. She has the big holes in her transom through which the massive hawsers, necessary for this work, are led.

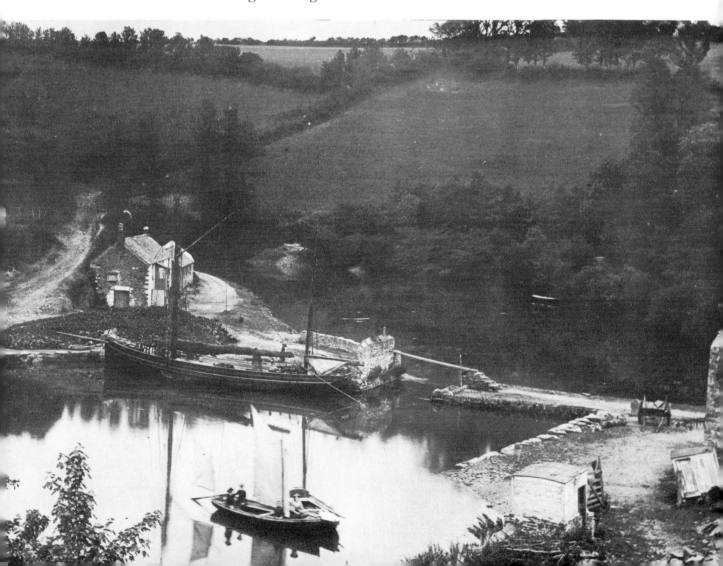

Section 9

SMALL PORTS OF SOUTH WEST ENGLAND

Before the development of motor transport often the most economical way to export produce from a country district or to bring in its imports was to ship them through a small port on a local coastline when there was a harbour and not simply an open beach as illustrated in the last section. For various reasons working in and out of such ports was not economical for steam ships and so small sailing vessels persisted in great numbers right up to the end of the 19th century in trades to small harbours all around the coasts of England, but particularly in Devon and Cornwall.

The small merchant sailing vessel was essential to the economy and prosperity of these little harbours. Sometimes there was a local fishing industry as well, but often the greater part of the business was the movement of cargo. The small ships were extremely important to the local community and in some cases, as at Appledore in Devon, illustrated later, established the characteristic way of life of the villages.

It was not possible to approach one of these small ports without seeing the tall masts of schooners and ketches, which lay, sometimes in their dozens, either in the floating harbours or with their masts raking

at different angles on the mud at low tide.

Many of these harbours were in areas attractive to tourists and photographs of them sold well as postcards. Francis Frith and his staff have left us very good records of some of them, especially in the south-west of England, and the ones I have chosen show harbours in Cornwall, Devon and Somerset.

Plate 82

This singularly fine photograph – notice the texture of the lock walls – was taken at the entrance to the Bude Canal in North Cornwall. It shows the channel leading from the open sea to the locks at low tide with two ketches aground in it. The nearer one appears to have her discharging gear ready to deliver cargo. The situation is probably one in which the neap tides are not big enough for the vessels to enter the canal beyond the lock so they are waiting until the tides grow bigger.

Notice that the lock gates are worked by two iron crab winches, one on each side, which are worked entirely manually. At the time this photograph was taken quite a fleet of schooners and ketches was owned in Bude. They were all small vessels because of the size of the locks, but they made an important contribution to the economy of the area. Bude developed as a shipping place not because of mines or clay works, like most other Cornish harbours, but simply because it was the only viable beach for many miles in either direction. It served an agricultural area and the two canals which were built to end in Bude in the early 19th century opened up to the harbour a big stretch of country from Holesworthy to near Launceston.

Nowadays only one vessel is owned in Bude and she never trades there. In some ways it seems ironic that the coastal trade in the west of England has been eliminated by road transport, now itself proving inadequate to deal with conditions it has itself created.

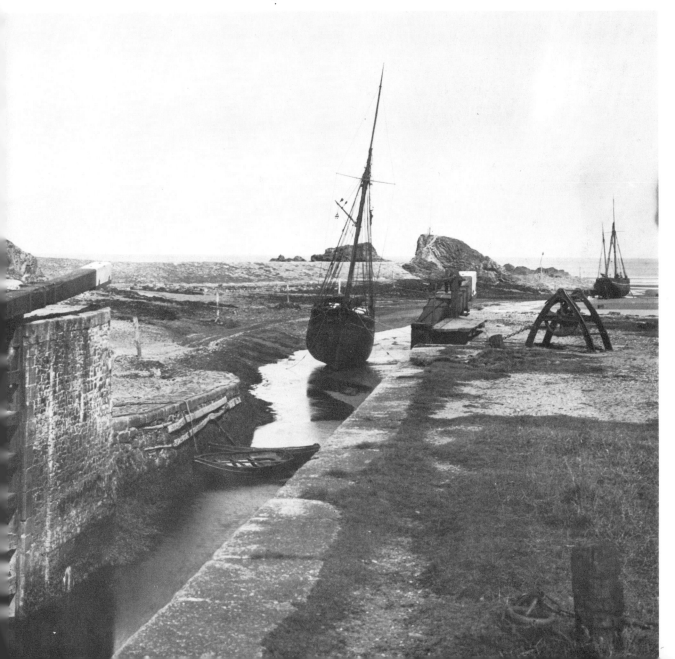

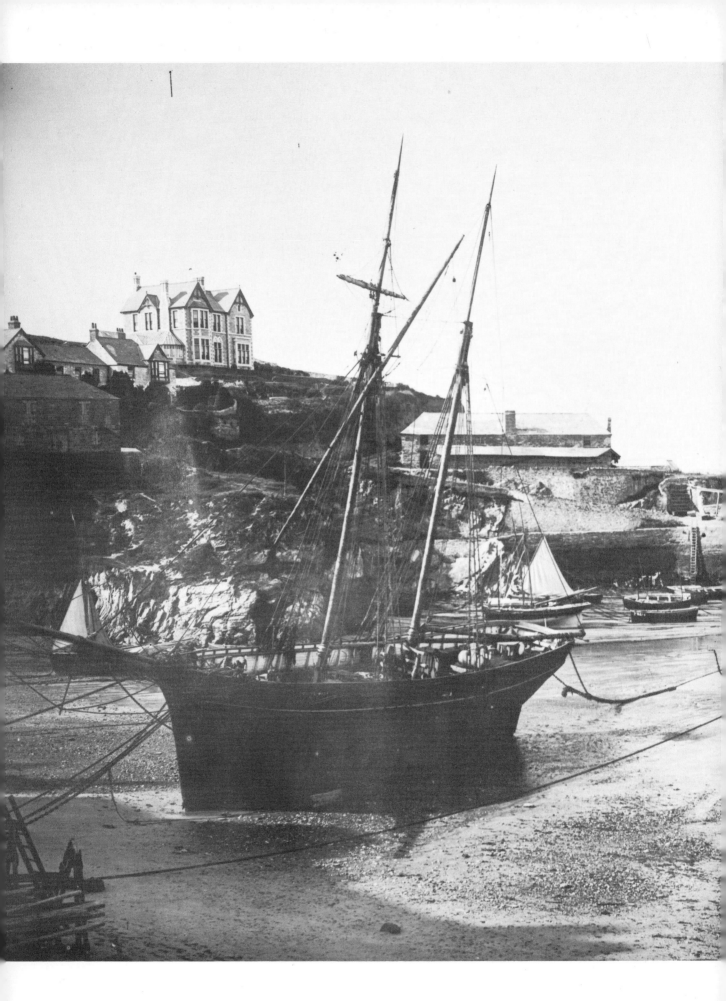

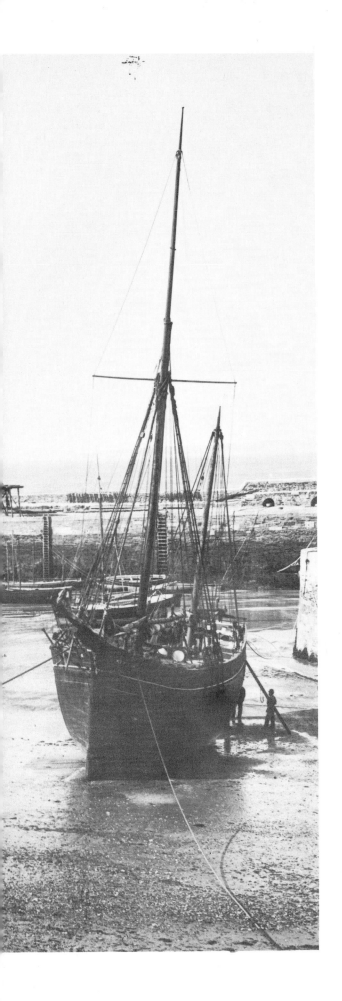

Plate 83

Probably taken in the early 1880s or the late '70s, this is one of the earliest photographs in the book. It shows the two-masted schooner *Driving Mist*, built at Newquay in 1863 and later owned in Appledore by Lewis Lawday, laid up. She has no sails bent and she has a lot of moorings out forward, including ropes and bower cables and one ordinary mooring rope from the port quarter as a bridle on to the very large harbour junk with chain cable through the starboard quarter pipe and fastened to the end of the junk in a manner which was customary to secure a vessel safely. Her foreyard has been cock-billed and her topsail yard braced right round so that other vessels can lie on the beach right alongside her. She is well and truly laid up and possibly was for sale when the photograph was taken.

The ketch is called the *Kittie* and the men standing by her on the floor of the harbour are probably tarring a seam. She has an enormously long fore topmast and a very short mizzen. She was built at Newquay in 1865 and since her sails are bent she was clearly still trading when the photograph was taken. She was owned by Nicolas Hockin of Newquay.

Newquay Harbour was built in its present form in 1838 and was last used to discharge a cargo in 1922 by the ketch *Hobah* of Bideford owned by Charles Lamey of Appledore. But for centuries before the 1830s it had been a harbour of refuge for vessels waiting for the tide to use the beach and creek which served this coast as shipping places before Newquay was developed. These were Porth (Plate 78) and the Gannel River (Plate 84). Newquay itself grew in the 19th century and became an important shipping place, exporting china, copper and tin and importing fertilisers, coal and feeding stuffs together with general cargoes. A considerable shipbuilding industry grew up with no less than four yards. Nearly 150 local vessels were insured by the local organisation set up by the ship owners which covered vessels from all over Cornwall. But Newquay nowadays earns a far more prosperous living as one of the leading holiday resorts in the south-west of England than it ever did as a centre of trade.

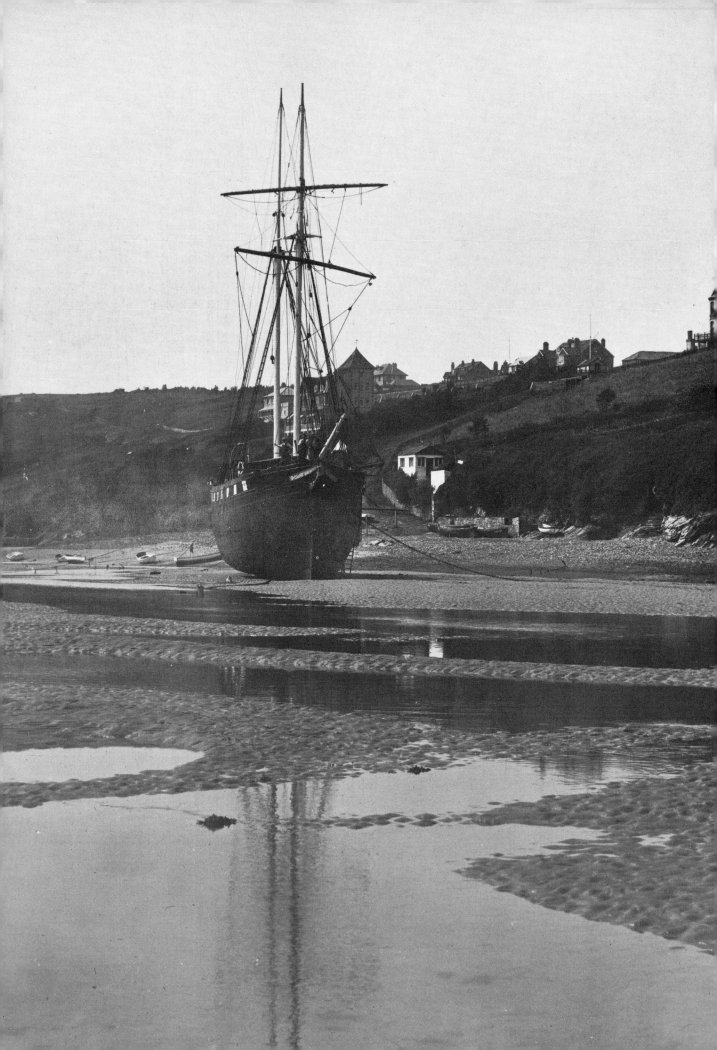

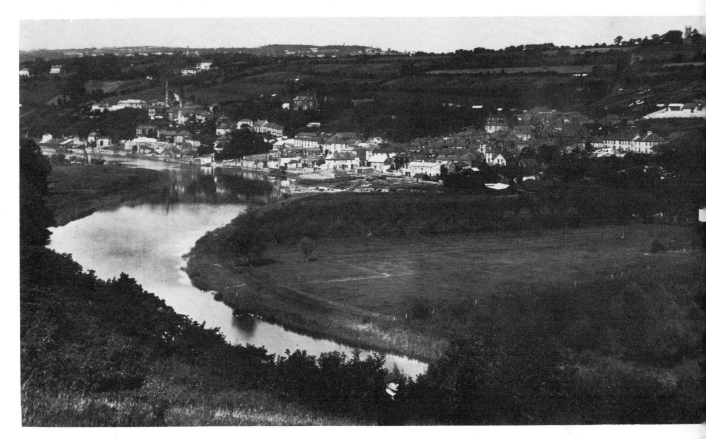

Plate 84 (Left)

The Gannel is a shallow arm of the sea reaching into the cliffs just west of Newquay in North Cornwall. With a hard sandy bottom it fills only for a short time on each tide, yet old quays at the head of the water show that a big trade was carried on here. It was indeed an important local shipping place before nearby Newquay harbour was built. In the middle of the last century there was an important and prosperous shipyard far up on the north side.

The schooner *Ada*, built at Ulverston in 1876, the last of the many vessels built there, spent her last years laid up in this backwater. Like so many of the small merchant wooden sailing ships illustrated in this section of the book she was not lost at sea or broken up, but simply disintegrated through old age in the quiet arm of the sea.

This photograph was probably taken in the 1920s, and is particularly interesting because it shows on the beach on the *Ada's* port side a little group of Cornish pilot gigs, including the *Trefry*. These gigs are still in use for recreational rowing and some of them are nearly a century and a half old.

Plate 85 (Above)

Seventeen miles or more from the open sea, but still on tide water, stands the little town of Calstock on the Cornish bank of the River Tamar. This place had a thriving trade in the export of the products of the local copper mines, arsenic works, quarries and brickworks, and it did not lose its importance until the First World War and the last of its trade until the Second. Nearby Cotehele Quay was the port for the industrial area around Callington, the agricultural and mining district of St Dominic. It too was used by sailing barges until the 1940s. There was a busy little shipyard, where the ketch is lying on the river bank opposite the town, run first by Edward Brooming and later by James Goss and his family. The ketch *Garlandstone*, launched from this yard in 1909, is still afloat and is currently being restored to her appearance as a merchant vessel for preservation at Portmadoc in North Wales.

Plate 86

ppledore in North Devon at the mouth of the Bideford river was an important centre of shipping and shipbuilding throughout the 19th century and this little town conducted a vigorous trade with North America from the early 17th century until the later 19th.

When this photograph was taken early in this century Appledore was still the home of a great fleet of schooners and ketches, a number of which are seen dried out on the mud at low tide. It is interesting to compare their shapes. The vessel in the immediate foreground, the *Express*, built in Jersey in 1862, has quite a sharp-shaped hull and heels over relatively steeply. The vessel immediately astern of her is shallower and beamier, and takes the ground much more comfortably, as does the vessel inside her. The men on the slip, veterans of the great days of the 1850s by the look of them, appear to have been deliberately posed. The planks at the top of the slip were used for the discharging of coal cargo into the store through the double doors visible behind the lamp post.

Appledore remained a place of small merchant sailing ships until the Second World War. Today it has two important shipyards and it is still a place of business rather than of tourism. Architecturally also it has retained much of the character of the small 19th-century seaport.

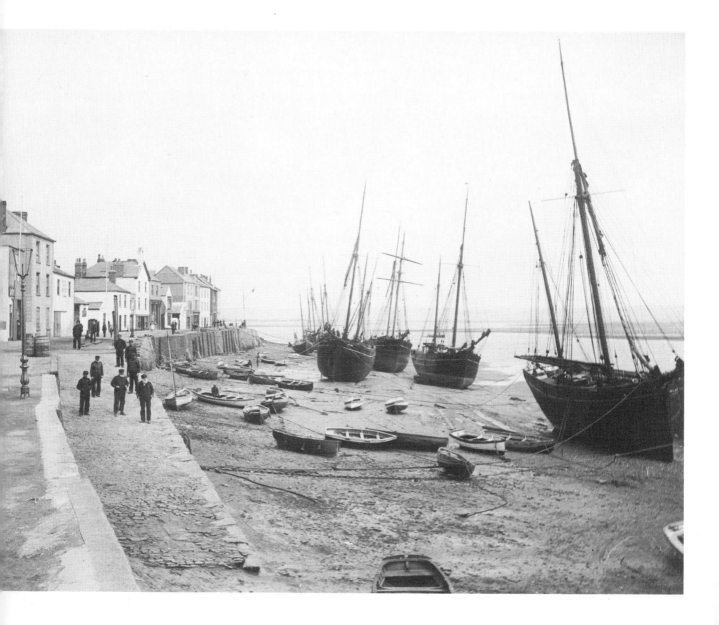

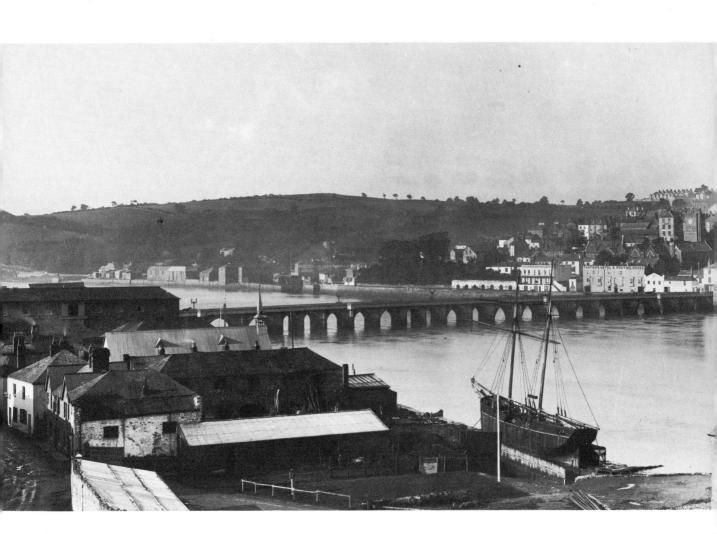

Plate 87

This is one of the oldest photographs in this book and was probably taken in the 1880s. It shows Bideford Long Bridge and Bideford-East-the-Water, then a shipbuilding place with a good deal of cargo coming and going. Bideford Long Bridge is shown with cast iron parapets as it was after a widening in 1864. This is one of the historic bridges of Britain and the original pointed arches can still be seen inside late 18th-century rounded ones. Many of the buildings in this photograph are still to be seen but they look completely different today, and the rutted muddy road, shown clearly in the left-hand corner of the picture, with nothing on it, is now a paved highway and always, like the bridge, thronged with motor cars, day and night. In the summer this is a trap for holiday makers who may have to wait here for some time to cross the bridge – still narrow, though it has been widened again since this photograph was taken.

Bideford, the port of which Appledore, seen in the last plate, is a creek now more important than the mother port itself, is one of the historic shipping places of Britain. From here fleets set out in the course of the first European attempt to establish permanent settlements in North America in the late 1500s and extensive trade with North America continued until late in the last century. Bideford was also an important shipbuilding place for centuries. It remains a prosperous market town serving a wide area and one of the most pleasantly situated places in the south-west of Britain.

The old schooner laid up with her jib-boom rigged in, her sails unbent and looking in a dilapidated state is the *John Harvey* of St Ives built at Hayle Foundry in 1834 by Henry Harvey of Hayle, the famous Cornish engineering firm. She was one of the first two vessels to be built by what would now be called their shipbuilding division. At the time the photograph was taken she was owned in Bideford-East-the-Water by William Sluman.

127

Plate 88

Pentewan nowadays is cut off from the sea by an extension of the sandy beach on which the surf is breaking in the background of this photograph. Although the harbour is still there it is now no more than an empty stagnant pool and the wilderness of saltings to the west is a holiday camp and caravan park.

In the early years of this century when this photograph was taken Pentewan was still a busy little port, frequently crowded with shipping. The photograph shows two three-masted schooners, four two-masters and a ketch. The harbour was built between 1820 and 1826 on a site to which there had been a beach trade for perhaps centuries. Westcountry trading smacks, like *The Sirdar* and the *Marie*, were still working into Pentewan until the Second World War, but since then silt and sand have choked up the navigable channel and what was once a busy centre of small shipping industry is now an object of wonder to holiday makers.

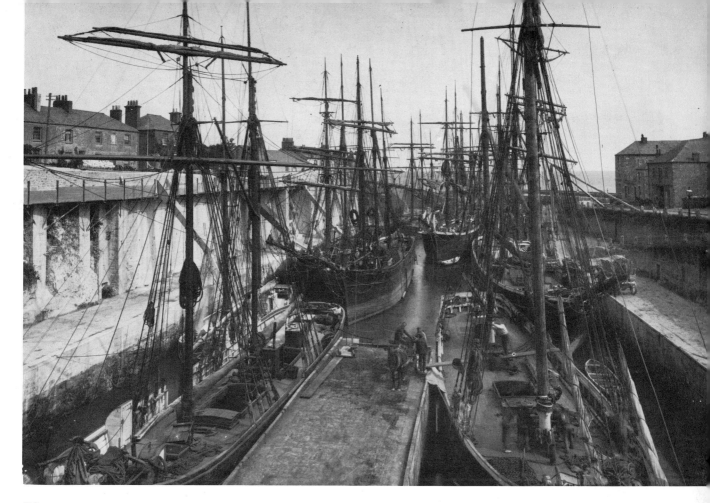

Plate 89

This picture shows Charlestown in South Cornwall, a port which exported china clay, a local product, and imported coal, taken in the days when sailing vessels used to be packed into it literally like sardines in a tin. When a ship had to be shifted from a discharging coal berth to a clay berth for loading, the dock master stood on the top of the wall around the harbour looking down on the decks of all the vessels and giving orders to heave ahead 6 feet or move back a few feet to another ship. It was said to have been like playing a game of gigantic draughts, but he always did the job in the end, because everybody co-operated and obeyed his orders.

In this photograph there is every kind of sailing vessel on the coast. There is a ketch in the immediate foreground to the right discharging coal into a cart by means of back-breaking labour at the hand winch – notice the extremely small size of her hatches, characteristic of these small sailing vessels. Also shown are a two-masted topsail schooner on the left, called *Baltic*, built at Peterhead in 1877 and owned in Dublin; a

three-masted schooner called the *Terrier*, built at Dartmouth in 1873, astern of her; and a barquentine between her and the dock wall. There is a brigantine astern of the three-masted schooner and another three-masted schooner astern of the barquentine; another ketch with a running bowsprit rigged in (essential in a harbour such as this because of space) lies between the *Baltic* and the dock wall. Notice that none of these ships seems to have any cover for the men at the helm; they were steered with a wheel in the open air without any protection, another indication of the hardships of the life, scraping a living from the sea, not by catching fish but by carrying cargoes from one small harbour to another for very small freights. The object like a sentry box in the bulwarks of the two-masted schooner in the foreground is the lavatory. Some of these little vessels had no lavatory and the crew had to be content with a bucket or nocturnal habits over the side.

Charlestown is still a busy commercial harbour.

Plate 90

This photograph of Fowey Harbour in the early 1890s was taken from a point much favoured by Frith and numerous other photographers for many years. The town of Fowey is on the right-hand side of the picture and the village of Polruan is on the left. Both were great shipping centres in the 19th century and much associated with the trade to the Mediterranean with general cargo, then across to Newfoundland with salt, and back to the Mediterranean, Portugal, Spain and Britain with cargoes of salted cod fish. The fleet of schooners owned by John Stephens, many of which had names beginning with 'Little' (*Little Secret, Little Mystery, Little Gem*, etc), was the greatest of the British schooner fleets, and was based here.

Four sailing vessels are lying at moorings; two of them are loaded, probably with cargoes of china clay taken in at Fowey, and two of them empty, probably waiting for cargo. The one in the foreground on the right-hand side of the picture is a large Scandinavian barquentine. She has her jibboom rigged in, which was not compulsory in Fowey because in such a big harbour there was plenty of room, but the master appears to anticipate a long wait for cargo because he has also sent down the topgallant and royal yards.

The brigantine astern of her is also Scandinavian and she too has a royal yard. She is loaded and waiting to sail. She is probably Norwegian, because alongside her is a boat which appears to be a Holmsbu pram of a type built on the Oslo Fjord and of which an example can be seen on display in the New Neptune Hall of the National Maritime Museum. It seems to be a good day for drying sails. The two schooners, one in the centre loaded and one lying to anchor light on the left-hand side of the picture in the middle distance, are also taking advantage of this. The light one is rigged as a single topsail and standing topgallant yard schooner; the loaded one is a double topsail schooner and she still has her wooden fenders hanging out on her port side.

There are now many more buildings on the hillside above Polruan, but otherwise in 80 years this view has changed little. Fowey is still a very busy commercial port, with a booming china clay exporting industry. But no sailing vessels come to load.

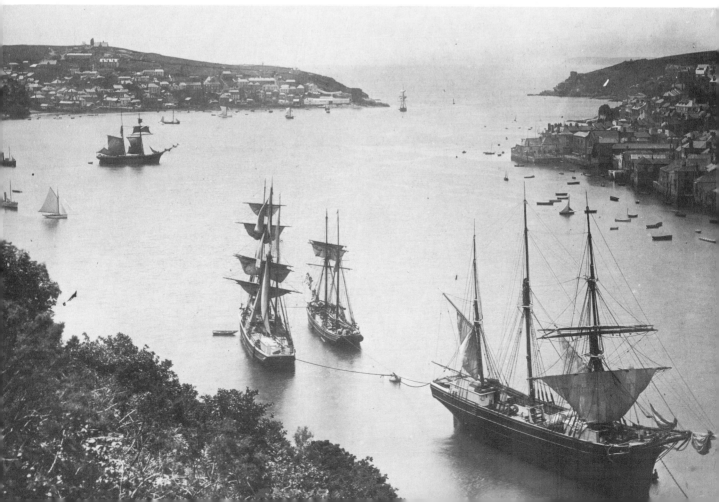

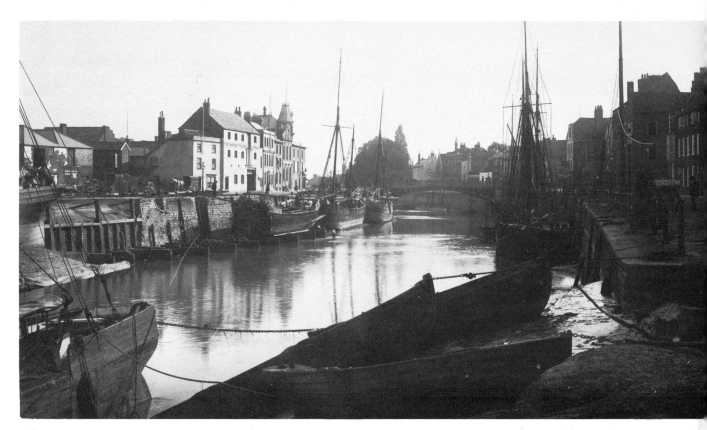

Plate 91

In the 1880s Bridgwater in Somerset was filled with the local sailing barges, called trows, which traded all around the upper reaches of the Bristol Channel east of Bridgwater and sometimes in earlier days to the westwards as well.

These trows were peculiar in that they had only short decks fore and aft; the main part of the vessel was open, like a boat, and protected from the short seas of the upper Bristol Channel by canvas side cloths which can be seen quite clearly at the side of the vessel in the immediate foreground. They were very poor sailers and depended principally on the strong tides of the Severn.

Another trow is clearly seen lying on the grid on the opposite side of the river. She is rigged right down with no masts or bowsprit, evidently undergoing extensive repair. She is the *Gloucester Packet* built at Stroud in 1824 and lost after a long and useful life in 1908. She was owned in the inland Gloucestershire village of Framilode. Astern of her, fully rigged as a ketch, lies the trow *Providence*, built right up the River Severn at Bridgenorth in 1805 and owned at the time the photograph was taken by Samuel Rowles of Frampton-on-Severn, Gloucestershire.

The two boats lying on the steeply sloping mud, side by side, in the foreground are particularly interesting. They are trow's boats, very heavily built and smooth skinned, as opposed to the usual clinker-built ketch's or smack's boat lying just under the camera. The trow's boats were never hoisted on board but towed behind the trow (see Plate 5). Their principal function was to enable the crew to tow the trow by rowing them with a line secured around the afterthwart, which was very heavy work indeed, but most necessary with vessels which worked the tides as these did and were poor sailers.

There are two other very interesting vessels in this photograph, one lying just upstream of the bridge and the other the stern of which is visible alongside the vessels on the right-hand side of the picture. These are both 'Bridgwater boats', the local flat-bottomed river barges which were probably the last descendants of the medieval cog in every-day use in Britain. They were clinker-built with a hard chine and flat bottoms, their sides slightly rounded, the stern sloping and pointed.

Section 10
RIVERS, BARGES & BOATMEN

The different kinds of local cargo vessel which worked in the rivers and estuaries around the coasts of Britain often showed an interesting process of evolution by which a class of river craft, while continuing to exist in its original form, could gradually have developed from it a new type of vessel, an efficient carrier in the conditions applying in a limited area of open water beyond the confines of the river. The local sailing barges of the 19th century were of considerable interest; not only were they efficient economic units by the standards of their time, but many of them were very handsome.

Besides the sailing barges, the rivers and estuaries of Britain employed small working boats by the thousand, ferry boats, passenger boats and small cargo boats. In the tenth and last section of this book some of these barges and boats, and their men, are shown as they were seen by Francis Frith and his photographers. These were the days before the development of motor transport made it more economic to load goods into a lorry and carry them 100 miles by road, than to load them into a cart, reload them into a barge, carry them 20 miles by water, discharge them into a cart and carry them to their eventual destination. When these photographs were taken, 70 or more years ago, the rivers and estuaries of Britain were alive with working vessels and boats. Today the whole world illustrated in this section of the book has completely vanished.

Plate 92

The River Thames at Surbiton with
Messenger's Boathouse in the back-
ground and two sprit-rigged London River
sailing barges in the foreground, one dis-
charging what appears to be coke into a
two-wheeled cart, the other, the *Glasgow*,
deep laden, probably waiting to discharge
in the same berth.

The London River sailing barge was a
great maid of all work in the transport
business of 19th-century south-eastern Bri-
tain. She carried every kind of cargo
generated by the trade and commerce of
the region and especially by London itself.
Working far up the Thames to the head of
tidewater and around the south and east
coasts she existed in her thousands.

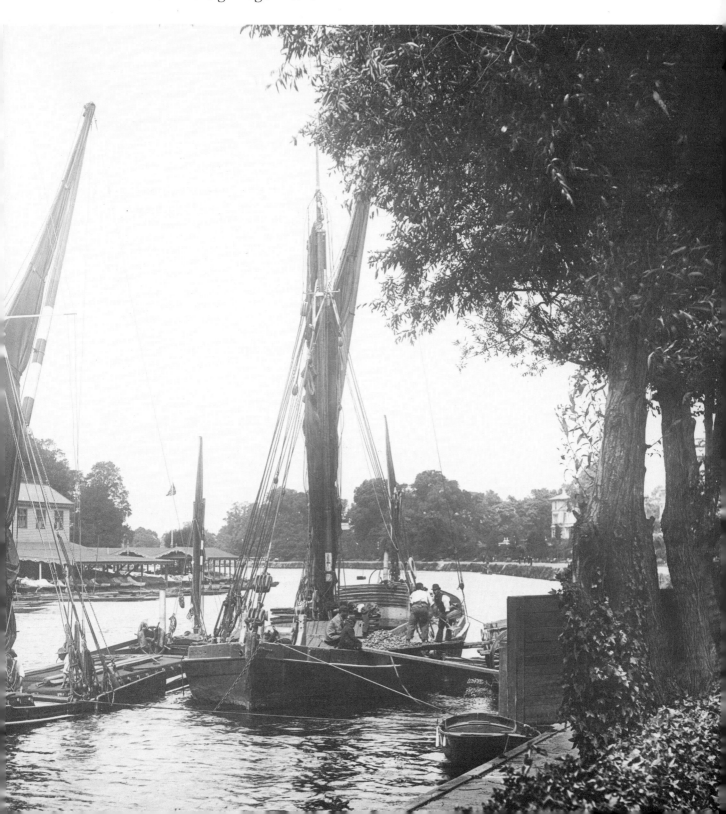

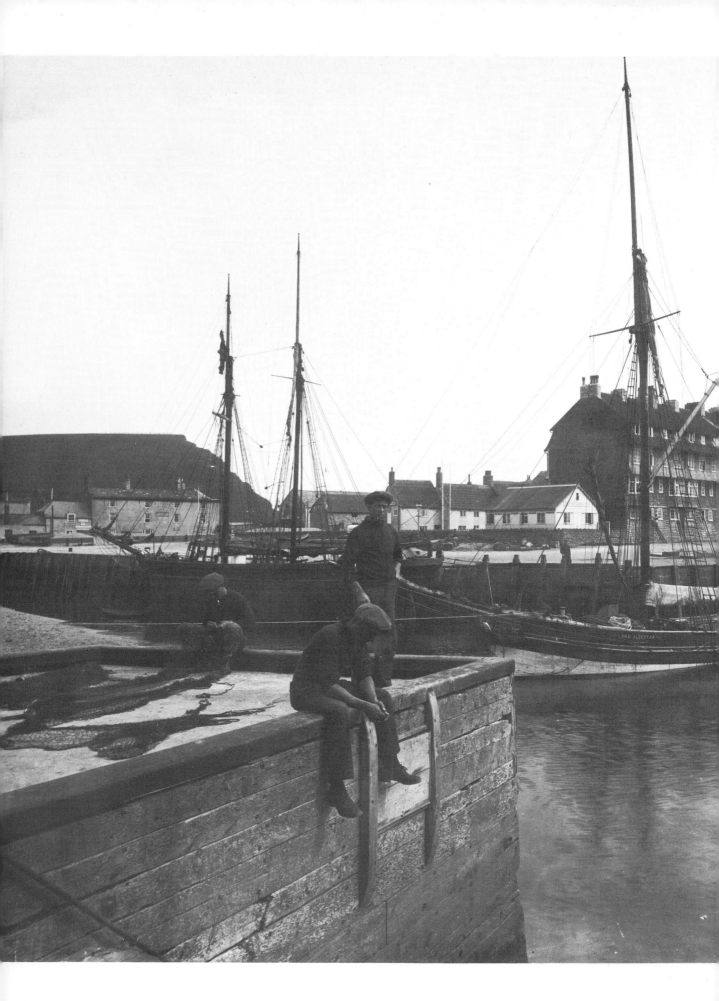

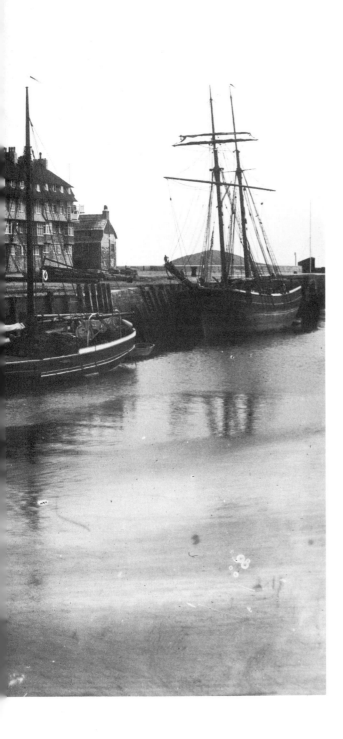

Plate 93

The vessel which developed 'from' (if such a simplification may be used) the sprit-rigged London River barges shown in the last photograph was the ketch-rigged coasting barge. In general appearance like the westcountry coasting ketches illustrated in Plate 77, she was different in details of rigging and in having a flat-bottomed hull like the sprit-rigged river barges and leeboards to enable her to sail to windward.

These features are clearly visible in this photograph of the *Lord Alcester*, built at Littlehampton by J. and W. B. Harvey in 1891. She was, in fact, bigger than almost all the westcountry ketches, and had she been built in Plymouth and Bideford with a round-bilged hull and an external keel she would probably have been rigged as a three-masted schooner, rather than a ketch. She is seen lying at Bridport, West Bay, Dorset, once an important little commercial harbour with an extensive shipbuilding industry.

Plate 94

Norfolk wherry is shown in this fine photograph. Wherries were shallow draught clinker-built boats about 50 feet long and perhaps 12 feet wide, with short decks fore and aft with waterways on either side and a great hatchway with very high combings – all clearly visible in this excellent photograph. She had a single mast from which was set a big loose-footed square sail from a very long gaff. Her rig was the simplest possible for her size, so that her mast could easily be lowered when a bridge had to be negotiated.

The wherry was a general transport vehicle of the area of Norfolk in which she worked. This one, the *Wigeon* of Wroxham, her hatch covers piled one on top of another, appears to be discharging cargo at a waterside mill. She has an interested audience of men and women. At the time, the *Wigeon* was owned and sailed by a man called 'Billie', one of the famous wherrymen of his day, and there are stories of her in the standard history of the wherries, *Black Sailed Traders* by Roy Clark, a book well worth reading.

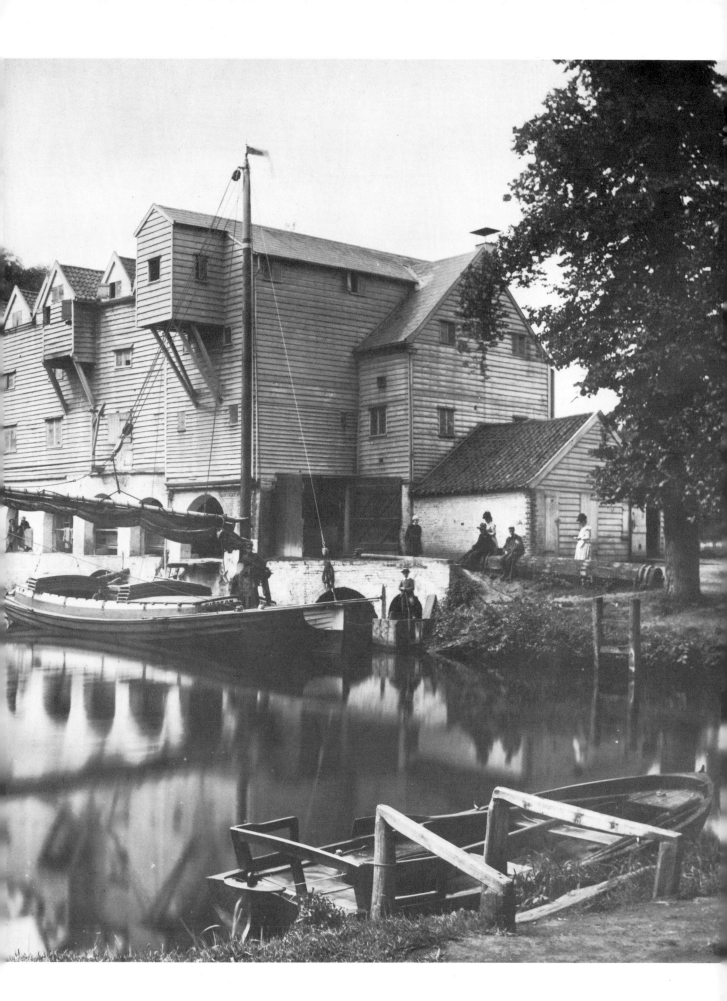

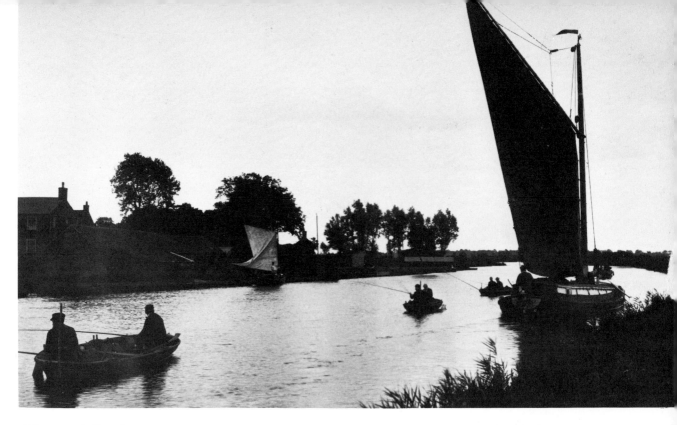

Plate 95 (Above)

The shape of a wherry's sail is very clearly shown in this photograph, as is also the fact that it was raised with a single halyard. There was a forestay, but no shrouds, and the mast was extra strong and thick. This wherry is slipping along in the evening, and nobody seems very concerned, although this large sailing vessel has, in fact, worked her way between the fishermen in the skiffs and the reeds, in a lane of water which appears to be not more than 20 feet wide. The Norfolk Wherry Trust has successfully preserved one of these vessels, the *Albion*, in her home waters, and so it is possible today to see a wherry's sail above the reeds looking very like this one did at the beginning of this century.

Plate 96

This is the steam chain ferry at Bowness-on-Windermere in the days of horse transport. The two-wheeled carts are crossing the lake while a woman continues to fish. She is a rarity; Victorian and Edwardian women did not usually go in for rod and line fishing. Also yachts of the Royal Windermere Yacht Club, some of which are shown in Plate 16, work their way round their racing course on the western side of the lake.

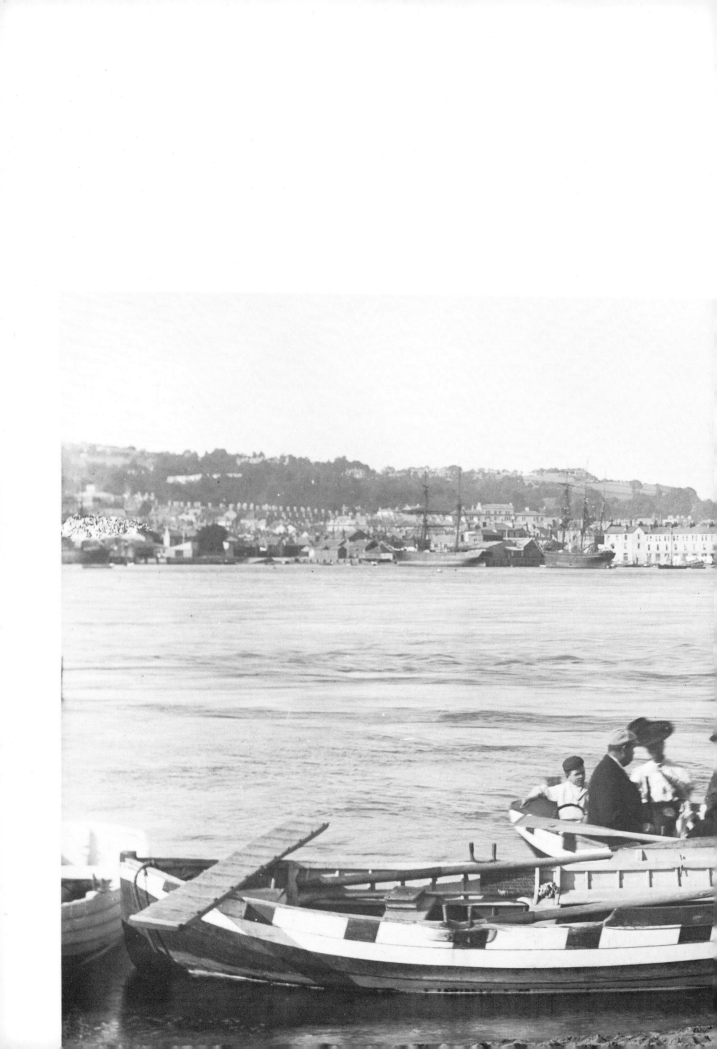

Plate 97

very river had its ferries. When people walked or travelled by public transport it paid to run a regular service across the lower reaches of a river to save a journey of miles around across a bridge.

These ferry boats are engaged in a service between Shaldon and Teignmouth across the River Teign in South Devon. Of particular interest is the line of painted ports with which each is decorated. Painted ports were adopted by merchant ships after the end of the Napoleonic Wars, initially to mislead potential enemies who seeing them at a distance would think them more heavily armed than they actually were, and later as a form of decoration which persisted amazingly into the 20th century and spread to every conceivable kind of craft besides big sailing vessels and steamers. Some trows, the River Severn sailing barges (see Plate 91), had painted ports; small schooners and ketches also had them and, as illustrated here, open boats were decorated in this way.

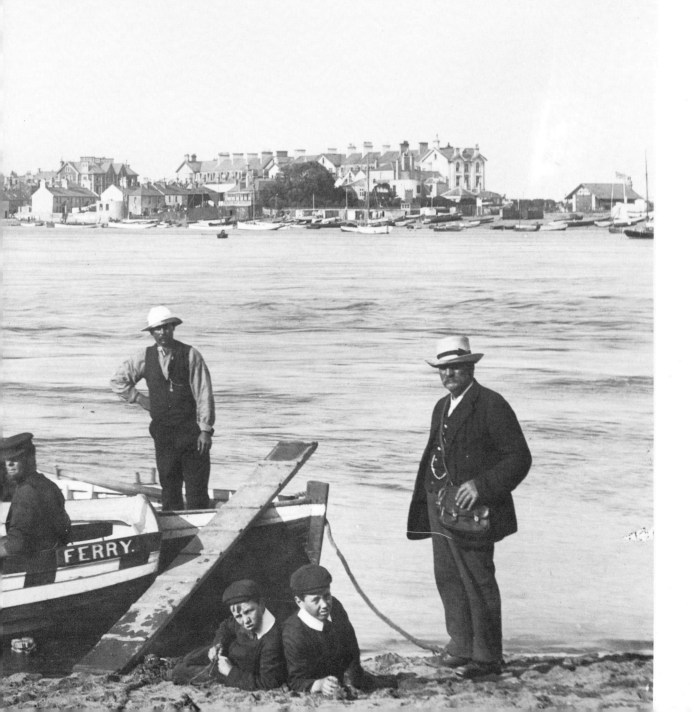

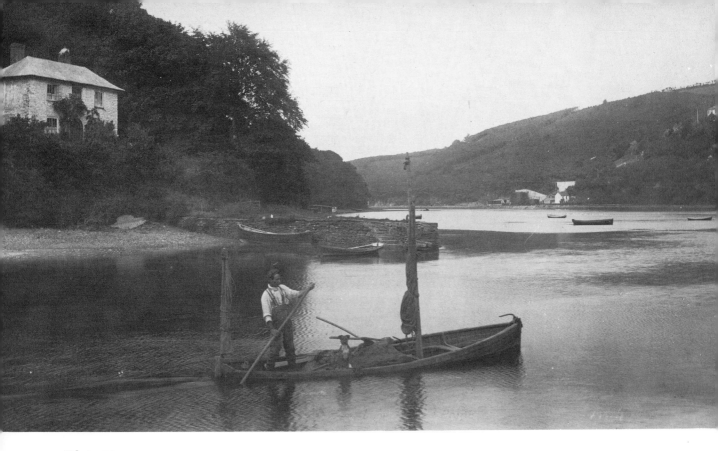

Plate 98

River trade was not confined to barges
and specialised cargo vessels. A lot
of cargo, especially of the type obtained
from the river itself (rotting leaf mould for
manure, sea weed for manure from the
river mouth, gravel from the river bed),
was collected and carried in open boats by
poor men who made a bare living fishing,
small holding, market gardening and work-
ing their boats as best they might.

The dredging of gravel from river beds
became a part-time occupation whenever
there was a demand for it for a building
project on the banks of the river system
concerned. A classic example is the building
of Devonport dockyard; when a Tamar
sailing barge was without a cargo and
there was building activity going on in
the dockyard, it would frequently pay to
use the barge to dredge up gravel from
the river bed and sell it at the dockyard,
rather than to tie the barge up and seek
some other occupation until times improved.

In this photograph, taken on the Dart
in South Devon, a local boatman is poling
a cargo of gravel, laboriously worked up
from the river, to a landing place where
there will be a sale for it. By this back-
breaking labour he might pick up a few
shillings for half a day's work.

142

Plate 99

This photograph was taken in the summer of 1901 and shows the yard of the Selby Shipbuilding & Engineering Co Limited on the river bank at Selby in Yorkshire, with two of the ships launched that year and another under construction on the slipway. The *Mabel*, on the left, was a trawler of 205 tons for the Steam Trawler Mabel Limited of Liverpool, eventually lost by submarine attack 60 miles SE of Sydero on January 10 1917. The right-hand ship is the *Carlyle*, which, shortly after her launch for a Liverpool firm, was purchased by the Straits SS Co Limited of Singapore and modified for employment on coastal services in Malayan waters. After being sold to Steam Traders Limited of London in 1916, she was also lost by submarine attack, on January 2 1917, five miles WSW of the Ile de Sein Light. There is a keel without her mast and rigging in the immediate foreground. It is a peaceful scene evidently taken on a Sunday when the yard was not working.

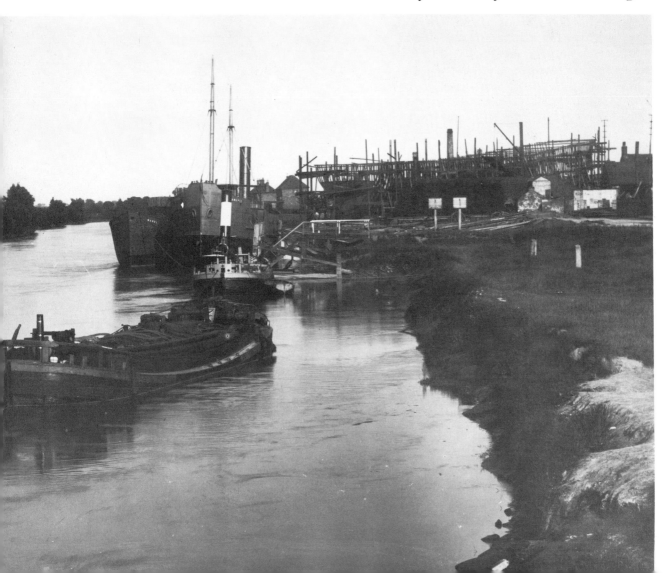

Plate 100

I have included this plate because it shows a typical working boat of the last century, rigged with the extremely simple standing lug sail and mizzen, to illustrate the fact that the standing lug required no rigging at all except its own halyard and sheet. It was about the handiest boat sail ever developed. One of our own family boats, a deliberate reproduction of a 19th-century working boat with nothing on board her that would not have been there on an equivalent vessel 70 years ago, is rigged in this way, and what she loses in ability to go to windward is very much more than made up for in con-

venience, handiness and economy in every other way.

Remember that these boats, like many of the boats and vessels shown in these photographs, were operated by poor men, who bought nothing that they could make themselves, who scraped a bare living from their boats and from the river or from the sea, a bare living which enabled them to exist in stone-floored cottages with no water and no sanitation, and little heating, where they and their families survived without hope of betterment, for generation after generation.

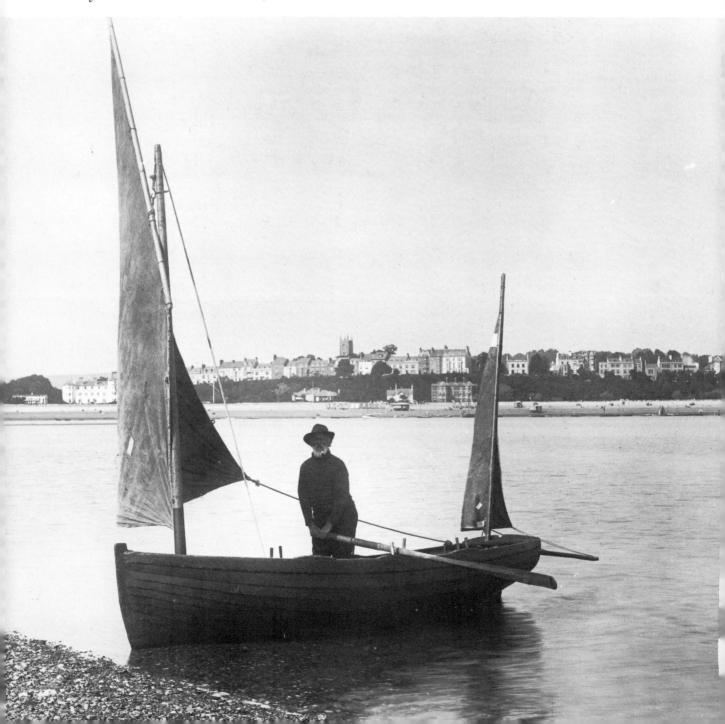